OIL & ACRYLICS MADE EASY

LEARN HOW TO USE OIL AND ACRYLICS WITH 18 STEP-BY-STEP TECHNIQUES AND PROJECTS, IN 200 PHOTOGRAPHS

HAZEL HARRISON

HERMES
HOUSE

This edition published by Hermes House, an imprint of Anness Publishing Ltd
Hermes House, 88–89 Blackfriars Road, London SE1 8HA
tel. 020 7401 2077; fax 020 7633 9499
www.hermeshouse.com; www.annesspublishing.com

If you like the images in this book and would like to investigate using them for publishing, promotions
or advertising, please visit our website www.practicalpictures.com for more information.

Publisher: Joanna Lorenz
Project Editor: Samantha Gray
Designer: Michael Morey
Photographers: Paul Forrester and John Freeman

Previously published as *Art Workshop: Oils & Acrylics*

ETHICAL TRADING POLICY
Because of our ongoing ecological investment programme, you, as our customer, can have the pleasure and reassurance
of knowing that a tree is being cultivated on your behalf to naturally replace the materials used to make the book you
are holding. For further information about this scheme, go to www.annesspublishing.com/trees

PUBLISHER'S NOTE
Although the advice and information in this book are believed to be accurate and true at the time of going to press,
neither the authors nor the publisher can accept any legal responsibility or liability for any errors or omissions that may
have been made nor for any inaccuracies nor for any loss, harm or injury that comes about from following instructions or
advice in this book.

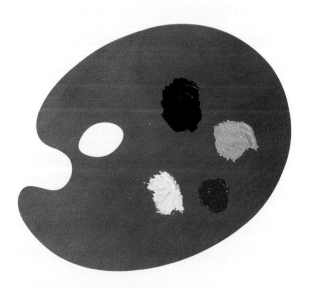

Contents

ABOUT OIL & ACRYLIC

Oil paint, although often seen as the traditional painting medium, is in fact younger than watercolour – or at any rate than a form of watercolour. The tempera paints which preceded oil and were used for both panel paintings and frescoes (wall and ceiling paintings) were made from pigments suspended in water and mixed with some form of glue, usually either egg yoke or casein, made from the curd of milk.

The idea of binding pigment with oil is often credited to the Flemish painter Jan Van Eyck in the early 15th century, but it is probable that other artists had experimented with similar ideas. Whatever the origins of the medium, it rapidly became popular. Tempera was a difficult medium to use, and the potential of oil-bound pigment quickly became obvious.

In the early days of oil painting, the paint was in the main used thinly, rather as

tempera had been, but the colours were much richer, achieved by a layering technique called glazing. The surface was smooth, with no brushmarks visible. Later on, however, artists began to use the medium with more appreciation for its inherent qualities, and the marks of the brush (and sometimes of the knife) became an important part of the finished picture. Rembrandt's paintings, for example, demonstrate a love for the paint itself and what it can do, while in the works of the Impressionists, the brushwork and manner of applying the paint are inseparable from the subject matter.

OIL PAINTS TODAY

A walk round an exhibition of oil paintings instantly reveals the versatility of the medium, and it is this quality which has made it so popular from its inception to the

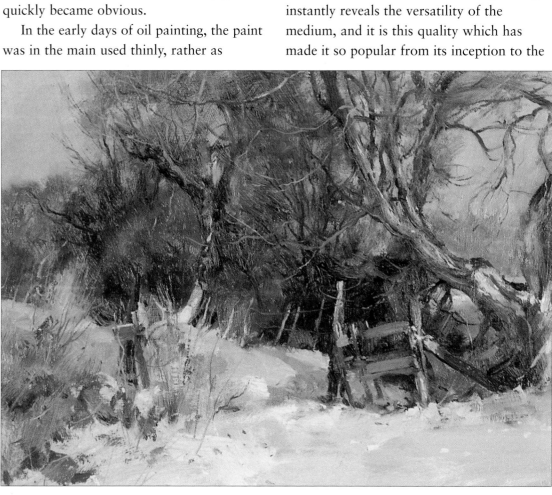

DAVID CURTIS
RED LANE,
NEAR DRONFIELD
(Left) *Brushwork is an important element in this oil painting on canvas; the brushstrokes follow the direction of the tree trunks and branches, describing them with great economy of means. Depth and recession are suggested by the contrast between thick and thin paint: on the right-hand tree the paint is thick and juicy, while for the area of blue distance it has been brushed lightly over the surface.*

GERRY BAPTIST PINES ON BEAUVBALLA

(Below) *This painting is also acrylic on canvas, but here the paint is slightly diluted with water to a consistency similar to that of gouache paint. The artist controls the juxtapositions of colour carefully, using complementaries such as yellow and mauve to create maximum impact while giving a realistic account of the landscape.*

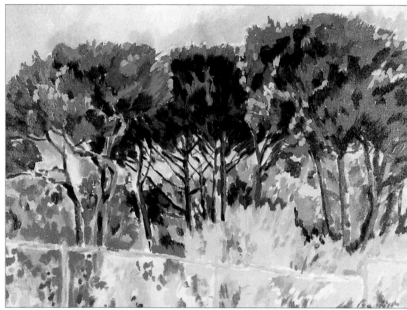

TED GOULD
SNOW SCENE
(Above) *While David Curtis has juxtaposed warm golden browns with the blues and greys of the snow, the colour scheme in this painting is cool throughout; the yellow of the hat and scarf provides the only touch of contrast for the blues, blue-greens, greys and grey-browns. The painting is in acrylic, used thickly on canvas. This artist works mainly in oil, and applies the same methods to his acrylic work.*

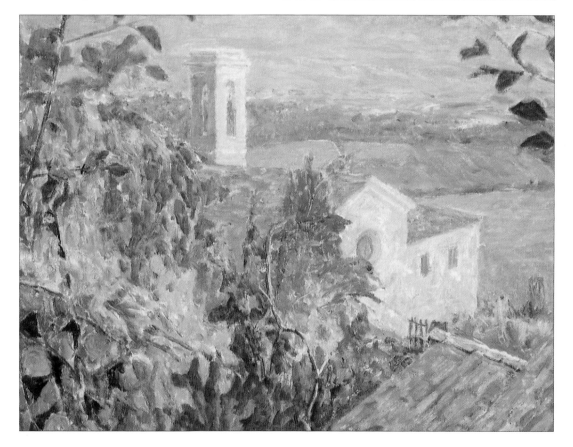

PATRICK CULLEN CHURCH, SAN DONNINO

(Above) *Some artists like to paint on a coloured ground, but when the paint is used thinly, as in this lyrical oil painting, the white of the canvas reflects back through the colours to give a luminosity more often associated with watercolour.*

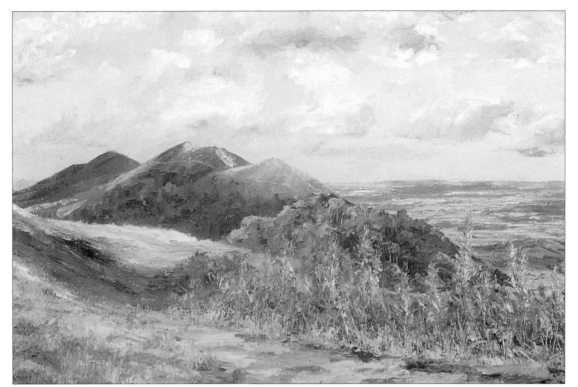

MALVERN HILLS
(Left) *This artist, well known for his sensitive portrayals of the English countryside, works in the traditional medium of oil paint on canvas but, instead of the usual brushes, he uses painting knives, which he has "customized" to create particular effects. Knife painting can achieve bold, dramatic effects, but also surprisingly delicate ones, as can be seen in this painting.*

present day. Any painting medium should be seen as the servant of the artist, and oil paints behave in such an obedient manner that no two artists need paint in the same way. Oils can be used thinly or thickly, applied with knives or brushes – or even your fingers – and you can work on a large or a small scale. You can also move paint around on the picture surface, and, best of all for inexperienced painters, you can scrape the paint off and start again.

In times gone by, artists had to employ assistants to grind the pigments laboriously to make up the paint, but today we have no such chores to perform. The paint comes to us in convenient tubes, so that outdoor work presents no problem. The colours are all manufactured to the highest standards possible and there is a wider choice than ever before. There are ready-made canvases and painting boards, as well as brushes to suit all styles and ways of working. Furthermore, new mediums to use with oil paints have made it possible to revive some of the old techniques, such as glazing, which had been largely abandoned by the late 19th century. The oil painter has never been in such a fortunate position.

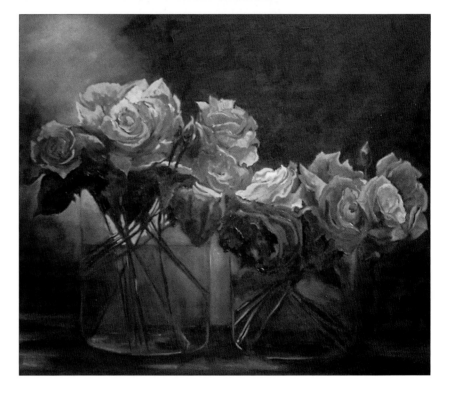

MADGE BRIGHT
VICTORIAN ROSES IN GLASS
(Above) *Once more, oil paint is the medium used for this lovely painting, which provides a perfect example of the skilful exploitation of a limited colour scheme consisting almost entirely of pinks and dark greens. In spite of its apparent simplicity the painting is meticulously planned and composed, with the mass of the flowerheads creating a strong, irregular shape across the picture, and the stalks arranged to introduce a contrasting linear pattern.*

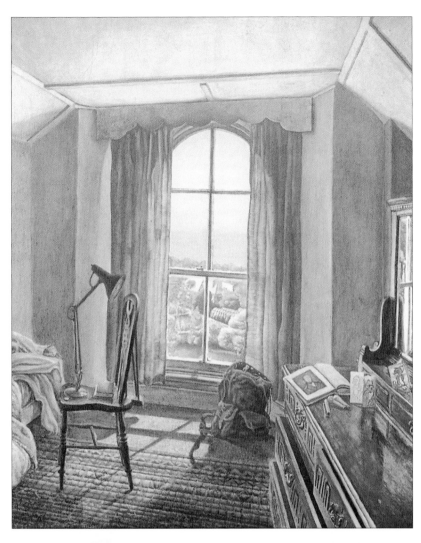

PAUL BARTLETT
ROOM 15, KATHMORE HOUSE, FALMOUTH

(Left) *Light is the primary theme of this picture, painted in oil on canvas. The colour scheme is similar to that of Karen Raney's painting (below), but here the artist has used a very different technique. The brushstrokes are almost invisible and every detail and texture is described in minute detail.*

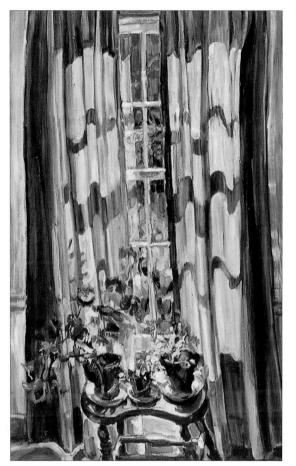

KAREN RANEY
CLAIRMONT ROAD

(Above) *Room interiors can make exciting painting subjects, providing opportunities for exploring the effects of light. In this painting, also in oil on canvas, the shadows thrown on the curtain by the window bars have created an intriguing pattern of light on dark, which the artist has made her central theme. She has chosen a tall-format canvas in order to stress the vertical thrust of the composition.*

STEWART GEDDES
ROSE-COLOURED HOUSE, PROVENCE

(Left) *In certain lights, brick and stonework can appear surprisingly rich in colour; the building here, which might have looked dull under a grey sky, has provided the artist with the inspiration for an essay in colour. Colours always appear more vivid by contrast, and he has introduced neutral colours to enhance the warm, glowing hues. The painting is done in oil on board.*

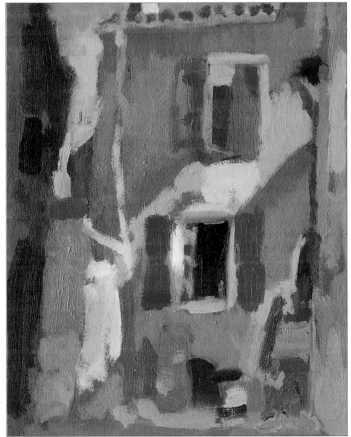

OLIVER BEVAN
SHARP CORNER

(Right) *Bevan paints both landscapes and urban scenes, using colour in a way that is not strictly naturalistic but which invokes a powerful atmosphere. In this oil painting, strong contrasts of tone and colour produce a highly dramatic effect, with a slight sense of menace reinforced by the two dark figures and the gravestone shapes in the foreground.*

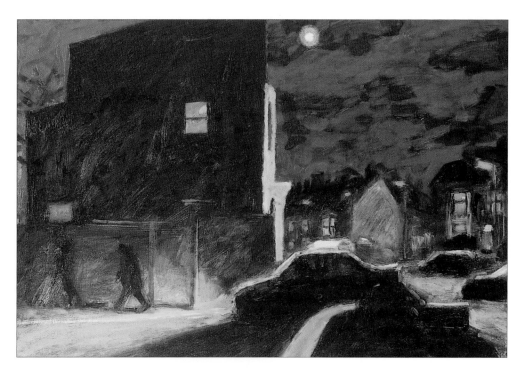

ANNE VANCATOVA
BLUE INTERIOR

(Left) *Painted in oil on canvas, this evocative and intriguing painting of an interior is a celebration of colour. An intense sky blue is used to cover most of the canvas, and form is picked out with a minimum of dark, linear marks which convey the composition's perspective and touches of yellow-green, red and white which hint at details of the scene such as the evening light outside the windows.*

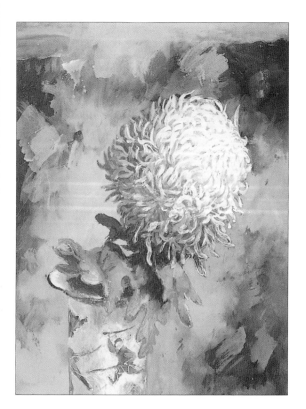

TIMOTHY EASTON
RESTORATION
(Right) *The degree of
control in this oil
painting is breathtaking,
with every detail and
texture minutely
described – notice
especially the peeling
paint on the open doors
and the leather jacket
worn by the figure in the
doorway. When figures
are included in a
painting they generally
become the centre of
interest, but here the
power of the geometric
pattern of brilliant blue,
near-black and golden
brown is such that the
figures play a minor
role; the painting can
almost be read as an
abstract composition
in colour.*

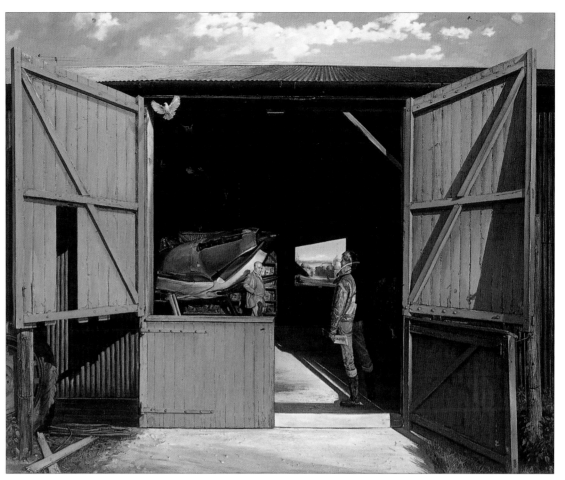

ROSALIND
CUTHBERT
GIANT
CHRYSANTHEMUM
(Opposite) *One of the
beauties of acrylic is
that, because it is not
oil-based, it can be used
in conjunction with
other water-based paints
as well as with various
drawing media.
Working on paper, the
artist has used acrylic
with gouache paint,
exploiting the contrast
of thick and thin paint
and adding touches of
texture and detail to the
flowerhead and vase by
using the effective
sgraffito technique.*

ACRYLICS

A by-product of the new plastics industry,
acrylics were invented in the 1950s. Perhaps
because they are such newcomers to the art
scene, a certain amount of prejudice against
them still exists in some quarters, which is a
pity, as they are as versatile as oil paints and
have some unique qualities of their own.

One of these – vital from the amateur
standpoint – is that they dry very quickly,
so that you can overpaint as much as you
like. You can, of course, overpaint with oils
but, because they are slow-drying, there is
always a risk of churning up the colours and
creating a muddy mess. Acrylics, once dry,
are immovable, so that each new layer
completely covers the one below without
picking up any colour from it. Another
advantage is that you can paint on more or
less anything, from paper and board to
canvas, and the surface needs no advance
preparation, or "priming".

Acrylic paints can be used as "imitation"
oils because they behave in much the same
way, but there are differences between the
two, both in handling and in make-up. All
paints are made from fine-ground pigment
particles suspended in liquid and bound
with a glue of some kind. In the case of
acrylics the liquid is water and the binder is
a form of plastic – a polymer resin to be
precise. Acrylics are thus water-based, not
oil-based and, if they need to be thinned,
you use water not oil. Likewise, brushes
used with acrylics come clean in water, not
white spirit.

The disadvantages of acrylics are that
changes to the picture can only be made by
overpainting, and the paint dries so fast that
it cannot be moved around on the surface to
any degree like oil paints can. Also, brushes
must always be left in a container of water
or washed regularly, otherwise they will be
ruined. However, the virtues of acrylics far
outweigh these minor vices, and those new
to painting could find them the perfect
medium with which to begin.

PAINTS, BRUSHES & MEDIUMS

Both oils and acrylics come in tubes, though some manufacturers of acrylics also produce them in pots, of about the same size as those used for poster paints. Tubes are the usual choice, but pots have the advantage of minimizing wastage. When

acrylic paints are squeezed onto the palette at the beginning of a working session, some paint is usually left at the end which is wasted, having become hard and unworkable. With pots, you can dip in as needed and replace the lid immediately. However, the paint is thinner than that in tubes and is thus less effective for thick, oil-painterly effects.

BRUSHES

Long-handled bristle brushes are traditionally used for oil painting and are equally satisfactory for acrylic. They are made in three basic shapes: flats, rounds and filberts, all of which make a different kind of brushstroke. Only experience will tell you which ones you prefer, so as with paint colours it is wise to begin with a small range – perhaps two of each type.

Most artists' kits include one or two soft brushes, which are used for small details as

well as for any flat, smooth areas of paint. Sables are the best, but they are expensive (and very easy to ruin), so start with one of the many synthetic substitutes, or a sable and synthetic mixture. There is an excellent range of white nylon brushes specially

formulated for acrylic painting, and these can also be used for oils.

OIL PAINTS

NYLON BRUSHES FOR
OIL AND ACRYLIC

MEDIUMS

Both oils and acrylics can be used straight from the tube, but often some medium is used to thin the paint or change its quality. Acrylics are water-based and are thus

A SELECTION OF MEDIUMS FOR OIL AND ACRYLIC

thinned with more water, while oil paints are diluted with turpentine, a mixture of turpentine and linseed oil, or with linseed oil alone.

Various special mediums are made for particular methods of painting. For both

initially, but you may want to try them later on, so we will be looking at their uses in the section dealing with techniques.

However, if you intend to try acrylics, there is one special medium you may find useful from the start. This is a retarder,

TUBE ACRYLICS

POT ACRYLIC

oil and acrylic, for example, there are glazing mediums which make the paint more transparent and thin it without causing it to become runny. For those who like to paint very thickly, impasto mediums bulk the paint out. You won't need any of these

which slows the drying time of the paint, allowing you to manipulate it more easily. It is only used for thick paint, as water affects its performance, but it is a great help for acrylic used in the "oil mode".

BRISTLE BRUSHES FOR

OIL AND ACRYLIC

PALETTES & PAINTING SURFACES

The palettes normally used for oil are made of wood and are either kidney-shaped or rectangular (to fit into the lid of a paintbox). Both have a hole for the thumb so that you can hold them comfortably when you work in the traditional standing position. But you do not have to work standing up, nor do you have to hold the palette. Many artists prefer an improvised palette such as a piece of thick glass or hardboard, which they place on a surface beside them, such as a low table or stool.

Glass is a popular choice for acrylic. Wooden oil-painting palettes are not suitable because the paint cannot be removed easily when dry; you need a non-absorbent surface. The palettes sold especially for acrylic are white plastic. Some people find these satisfactory, but others dislike them, as the glaring white surface makes it difficult to judge the colours when mixing them.

There is one other special palette made for acrylic work, which is particularly useful if you are painting out of doors. This "Stay-Wet" palette is a shallow plastic tray in which there is a top layer of non-absorbent paper and a lower layer of blotting paper. Water is poured into the tray below the blotting paper, the paints are laid out on the top layer, and enough water seeps through from the blotting paper to keep them moist. There is also a transparent plastic lid that fits over the tray, keeping the paint fresh more or less indefinitely.

WORKING SURFACES

The best-known surface for oil painting (also used for acrylic) is stretched canvas – that is, some form of cotton or linen material supported by a wooden frame. Canvases are not cheap, but you can stretch your own quite easily. The larger art shops sell canvas

KIDNEY-SHAPED
WOODEN PALETTE

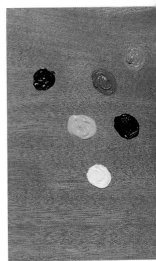

RECTANGULAR
WOODEN PALETTE

by the metre, and stretchers can be bought in pairs. Another method is to stick the material (which does not have to be canvas; you can use old sheets) onto a stiff board such as hardboard (Masonite). You can do this with animal skin glue (size) or with PVA medium diluted with water.

A primer, or ground, is a layer of paint on top of the canvas or board which, in the case of oil paint, prevents the oil from seeping into the material and damaging it. Most canvases and painting boards now made are intended for both oil and acrylic.

There is a variety of different boards sold for oil and acrylic painting, the best of which are canvas-textured. They form an inexpensive alternative to canvases. You can also paint on hardboard (Masonite) or tough cardboard, but for oil painting you need a primer. The best all-purpose one is acrylic gesso.

You can paint on paper too. For acrylic applied fairly thinly, ordinary cartridge (drawing) paper is fine, but for oil, or acrylic built up thickly, use something more solid, such as heavy watercolour paper.

CANVAS BOARD

PAINTING KNIVES

Stretching unprimed canvas

1 When you have assembled the stretchers, use a piece of string to check both diagonal measurements, taking it across one way and then the other. If the second measurement differs from the first, the rectangle is out of alignment.

2 Place the stretcher on the canvas, make pencil marks all the way round at least 5 cm (2 in) from the stretcher, and cut out the canvas.

3 Hammer a tack into the centre of the first long side, and then another one on the opposite side; continue from the centre outwards. You can use a staple gun, but tacks are easier to remove if re-using the stretchers.

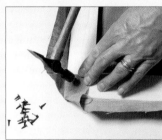

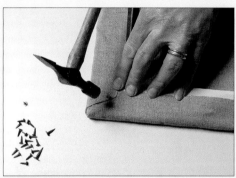

4 There are various ways of dealing with corners, but this is one of the simplest. Fold in the corner of the canvas neatly and then hammer in a tack to hold it in place.

5 Fold in the remaining flaps of canvas and tack again. Unprimed canvas should not be stretched too tightly because the priming will shrink it. To stretch ready-primed canvas, you need canvas pliers.

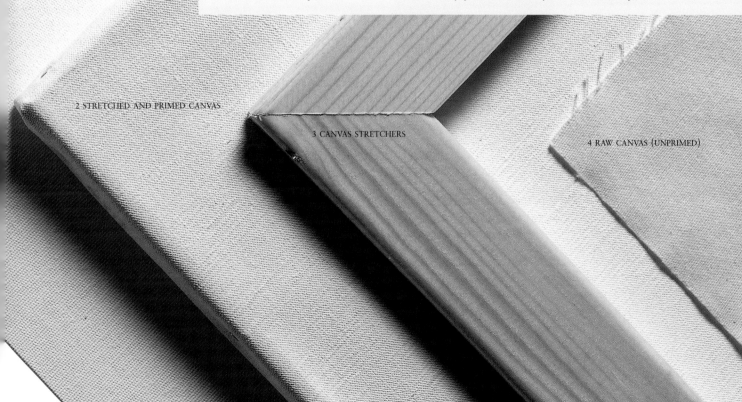

2 STRETCHED AND PRIMED CANVAS

3 CANVAS STRETCHERS

4 RAW CANVAS (UNPRIMED)

PRIMARY &
SECONDARY COLOURS

Most non-painters know something about colour, for example many people can name the colours of the spectrum (which are those you see in a rainbow). There are seven of these: violet, indigo, blue, green, yellow, orange and red; they are produced by the dispersal of white light through a prism – different colours have different wavelengths. But while this kind of knowledge may have its uses in photography or colour printing, it cannot be applied usefully when it comes to painting. The colours of light are absolute, there is just one red, yellow, blue and so on, but artist's pigments are not.

MIXING SECONDARIES

The spectrum colours have given rise to the well-known belief that it is possible to mix

any colour under the sun from the three primary colours alone: red, yellow and blue. The colour pictures in this book are indeed produced from just these three colours (plus black), but paints simply do not work in this way. In colour printing a series of tiny dots of pure colour mixes in the eye (optical mixing), but paints have to be physically combined. More important still, pigments are not pure; there are different versions of each primary colour, so which red, blue and yellow would you choose for mixing up another colour?

The first step to successful colour mixing is to recognize the differences between the primary colours; only then can you discover how to mix the best secondary colours – mixtures of two primaries. If you look at the reds, yellows and blues on the starter

Mixing secondary colours
(Opposite) The top row shows mixtures of "like" primaries – those with a bias towards each other – and the bottom row shows the more muted colours produced by mixing unlike pairs of primaries. In each case the primary colours are shown on the right and left, and the mixtures in the three central divisions. The mixtures nearest to the primary colours have a higher proportion of this colour, while for the central division the colours have been mixed in equal proportions.

A STARTER PALETTE

As a general rule it is wise to begin with as few colours as possible and build up gradually. As you become more experienced you will discover which colours you find difficult or impossible to mix, and you can add to your range accordingly. It is virtually impossible, for example, to achieve good purples and mauves by mixing colours, so artists who specialize in flower painting usually have one or two purples as well as some special reds. The colours shown here will be quite adequate to begin with. They are available in both oils and acrylics, although some acrylic ranges use different names for the colours. For example, some makes of acrylic do not include viridian, but there is a similar colour called phthalocyanine green.

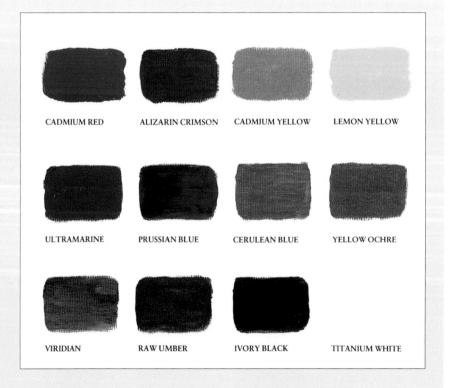

CADMIUM RED ALIZARIN CRIMSON CADMIUM YELLOW LEMON YELLOW

ULTRAMARINE PRUSSIAN BLUE CERULEAN BLUE YELLOW OCHRE

VIRIDIAN RAW UMBER IVORY BLACK TITANIUM WHITE

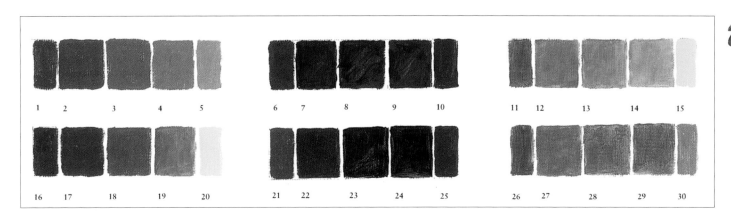

1 CADMIUM RED 2,3 AND 4 MIXTURES 5 CADMIUM YELLOW 6 ALIZARIN CRIMSON 7,8 AND 9 MIXTURES 10 ULTRAMARINE 11 CERULEAN 12,13 AND 14 MIXTURES

15 LEMON YELLOW 16 ALIZARIN CRIMSON 17,18 AND 19 MIXTURES 20 LEMON YELLOW 21 CADMIUM RED 22,23 AND 24 MIXTURES 25 ULTRAMARINE 26 CERULEAN

27,28 AND 29 MIXTURES 30 CADMIUM YELLOW

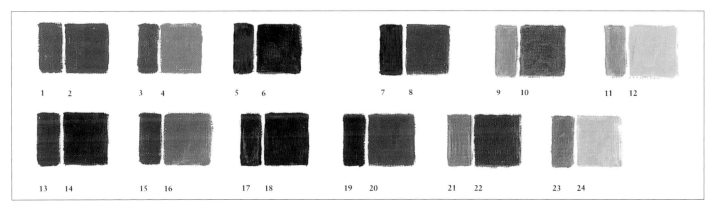

1 ORANGE (CADMIUM RED AND YELLOW) 2 PLUS BLACK 3 ORANGE 4 PLUS WHITE 5 PURPLE (ALIZARIN CRIMSON AND ULTRAMARINE) 6 PLUS BLACK 7 PURPLE 8 PLUS

WHITE 9 GREEN (CERULEAN AND LEMON YELLOW) 10 PLUS BLACK 11 GREEN 12 PLUS WHITE 13 MUTED ORANGE 14 PLUS BLACK 15 MUTED ORANGE 16 PLUS WHITE

17 PURPLE BROWN 18 PLUS BLACK 19 PURPLE BROWN 20 PLUS WHITE 21 GREEN 22 PLUS BLACK 23 GREEN 24 PLUS WHITE

Adding black and white *(Above)* These "swatches" give an idea of the large range of colours which can be made by adding black or white to mixtures. The 50:50 mixtures of primary colours shown in the chart above have been taken as the basis, with first black and then white added.

palette, you will see that they have different biases. One red leans towards purple or blue, and the other is more orange; lemon yellow is greener than cadmium yellow; ultramarine is slightly redder than cerulean or Prussian blue. The most vivid secondary colours are made by mixing primaries which are biased towards each other. You cannot make a good, bright orange, for example, with lemon yellow and alizarin crimson, or a good purple with cadmium red and ultramarine.

Making charts like the ones shown here, using the six basic primary colours, first on their own and then with the addition of black and white, will teach you a great deal about colour. As well as finding out how to make bright secondary colours, you may discover some useful mixtures for more muted effects. If so, try to remember them, as many paintings are spoilt by muddy, characterless neutrals. For example, an interesting grey is often made from a mixture of colours, not black and white.

USING A RESTRICTED PALETTE

O
I
L
&
A
C
R
Y
L
I
C

Painting with a limited range of colours is an exercise often set in art schools. In this case the idea is to use only the six basic primary colours: cadmium red, alizarin crimson, cadmium and lemon yellow, ultramarine and Prussian blue; plus white. You are not allowed black because, although a useful colour, it is also a seductive one; you may feel tempted to take the easy way out by adding it whenever you want to darken a colour, and this can lead to muddy, dull mixtures. White is permitted because there is no other way to lighten colours when you are using opaque paints, but you may discover that white is not always the answer. Adding white to red, for instance, turns it pink, so it is sometimes better to add yellow instead.

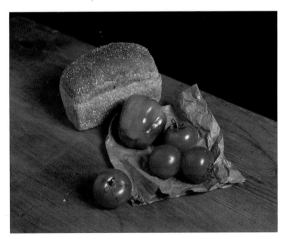

Choose a simple still-life group like the one shown here, but make sure you have plenty of colour contrast and some good dark areas to test your ability to make dark colours without black. You can use either oil or acrylic – the exercise is about mixing colours rather than handling paints.

COLOURS USED (OIL PAINTS) *titanium white, Prussian blue, alizarin crimson, ultramarine, cadmium red, lemon yellow, cadmium yellow*

Still life in six hues

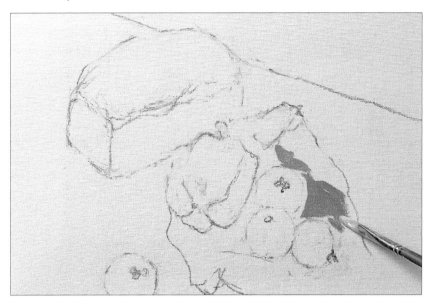

1 *The colour used here, which looks very similar to yellow ochre, has been mixed from white, lemon yellow and a little cadmium red.*

2 *For the tomatoes, the artist uses a mixture of both reds, with an added touch of lemon yellow for the lighter areas. He leaves the white of the board to show through for the highlights.*

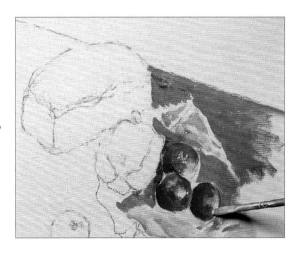

3 *The basic green for the pepper is ultramarine and cadmium yellow, two colours which can be mixed in varying proportions to produce a good range of greens.*

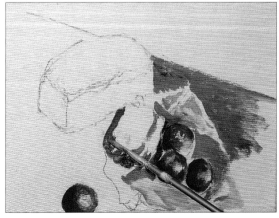

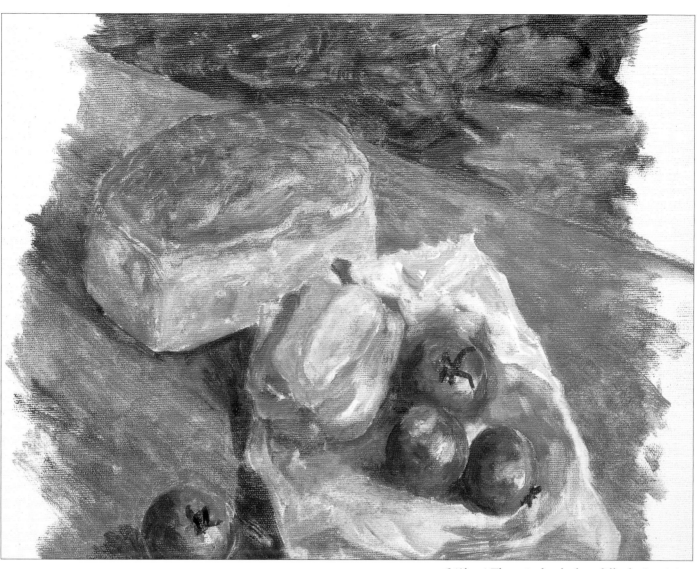

6 (Above) *The artist has had no difficulty in mixing all the colours in the group from these six, and could even have reduced the number to five, by excluding the Prussian blue.*

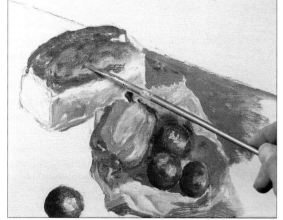

4 *The brown for the loaf of bread is similar to the colour used in Step 1, but slightly darkened with small additions of alizarin crimson and ultramarine.*

5 (Right) *Prussian blue, a very strong, dark colour which must be used sparingly, is now mixed with both reds and yellows for the background. A similar mixture, but with more Prussian blue, was used for the leaves on the tomatoes.*

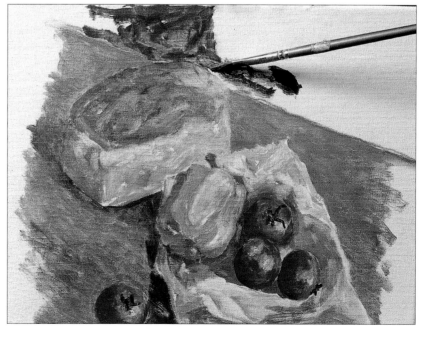

COLOUR RELATIONSHIPS

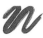

Establishing how to mix colours similar to the ones you observe is a vital step in the business of learning to paint, but you also need to understand something about how colours relate to each other. No colour exists in isolation – it is defined by juxtaposition and contrast with other colours. An orange or lemon placed on a neutral-coloured or dark cloth shines out because of the strong contrast, but the same fruit on an orange or yellow cloth forms no contrast, and thus creates little impact.

The fruit on a dark cloth would make use of contrasts of tone, which means the lightness or darkness of a colour. Tonal contrasts are important in painting, but there are other kinds of contrast too. Bright colours can contrast with neutral ones, and so-called "warm" colours with "cool" ones.

TEMPERATURE

Artists often describe colours in terms of "temperature", a visual and partially subjective quality that cannot be measured. Blues, blue-greens and blue-greys are cool, while reds, yellows and colours with red and yellow in them are warm.

Warm–cool contrasts are a way of creating the impression of space and recession in a painting. This is because the warm colours tend to advance to the front of the picture and the cool ones to recede further into the background.

But everything in colour is relative; even a colour ordinarily described as cool may lose its recessive habit if there is an insufficient contrast of warm colours. To complicate matters further, there are warm and cool versions of each colour. Ultramarine, which has a red bias, is warmer than cerulean or Prussian blue, and cadmium yellow is warmer than the slightly acid lemon yellow, which leans towards green.

NEUTRALS

These colours, the greys, browns, beiges and all the indeterminate ones in between, are often dismissed as unimportant. But, in fact, they have a vital role to play: they act as a foil for the bright colours and provide a framework for them.

The trouble with neutrals is that, because they are often difficult to analyse, it is hard to know which colours to start mixing. Furthermore, they are only neutral by virtue of contrast; for example, a greenish grey that takes a definite back seat when juxtaposed with red can look quite vivid when set against the ultimate neutral – a mixture of black and white.

Apart from the latter, which has no colour at all and should seldom, if ever, be used in painting, all neutral colours have their own colour biases. Greys are yellowish, brownish, slightly blue or tending towards mauve. This means that they must fit in with the colour bias of your painting. A useful device is to scrape your palette with a palette knife halfway through a working session and use this subtle colour mixture for neutrals. This ensures that the neutrals, being a mixture of all the colours used, will work in the context of the painting. You can do this only in oil, unfortunately, as acrylic dries too quickly on the palette.

Another good way of neutralizing a colour is to use its complementary. Complementary colours are those that are opposite each other on a colour wheel: red and green, violet and yellow, orange and blue. When these pairs of vivid opposite colours are mixed together they cancel each other out, making subtle neutrals that vary according to the proportions of the colours used. Successful neutrals always give a painting much more impact.

Warm and cool colours
As can be seen here, the warm colours, the reds, oranges and yellows, push forward in front of the cooler greens and blues. However, the orange does not advance as much on warmer blue.

Relative values
The colours in the centres of the first two squares are cool, but do not recede because the surrounding colours are cooler still. In the second pair, all the colours are warm, but the alizarin crimson and lemon yellow are cooler than the orange.

Neutrals
All the colours shown in the swatches are neutral, made from black and white with small additions of other colours. Seen in isolation they do not seem to be any particular colour, though some have biases towards red, green or blue. However, the squares at the bottom show how differently they appear depending on their surroundings. In the first and third squares a neutral colour is shown against a vivid background, while in the second and fourth the background is a neutral grey made from black and white.

ORANGE ON ULTRAMARINE

CADMIUM RED ON BLUE-GREEN

ORANGE ON CERULEAN BLUE

LEMON YELLOW ON GREEN

ULTRAMARINE ON PRUSSIAN BLUE

YELLOW-GREEN ON BLUE-GREEN

ORANGE ON ALIZARIN

CADMIUM YELLOW ON LEMON YELLOW

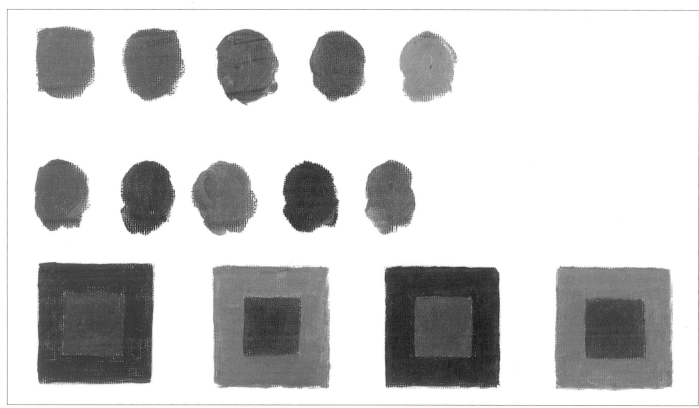

NEUTRAL BROWN ON CADMIUM RED SAME COLOUR ON GREY NEUTRAL GREY ON ULTRAMARINE SAME COLOUR ON GREY

PAINTING WHITE

n There is no better way of learning how to analyse and mix neutral colours than by painting one or two bright-coloured objects on a white background. You will also discover how radically light affects colour. Dark colours absorb the light but white is reflective, so when you look at a white object you see a marvellous range of subtle colours and probably very little pure white, or even none at all. The colours vary according to the kind of light you are working under, and on the objects, which can throw colour into the nearby shadows. Unfortunately, as the light changes so do the colours – a particular problem if your group is set up near a window. But it is a challenging task and well worth trying.

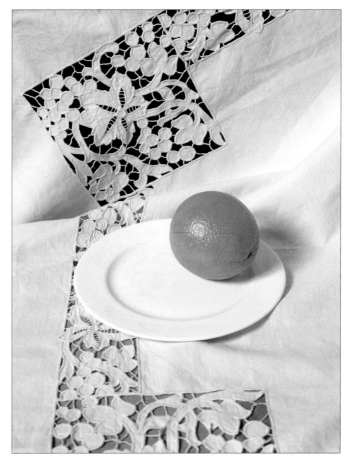

COLOURS USED *black, ultramarine, cerulean blue, Indian red, cadmium red, Venetian red, burnt umber, yellow ochre, cadmium yellow, lemon yellow, titanium white*

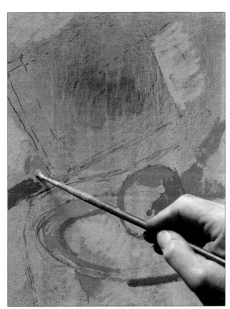

1 *As the orange is the brightest colour in the group, it has been blocked in first. This provides a key, enabling the artist to assess the grey-greens and blue-greens for the plate and background.*

2 *He moves on to the area of strongest tonal contrast, drawing in the pattern of the cloth with a fine sable brush.*

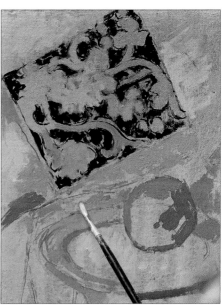

3 *As he works, he carefully assesses one colour against another. The greys of the cloth are far from being colourless, although they are neutral in comparison with the orange.*

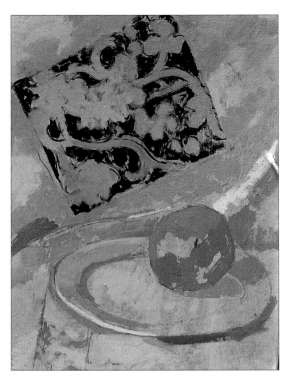

4 *The middle tones of the cloth have been established before the lightest areas, where the folds of the cloth catch the light. Here the artist has used pure white, but has painted lightly so that the brushstroke is broken up by the texture of the canvas, and a little of the underlying colour shows through.*

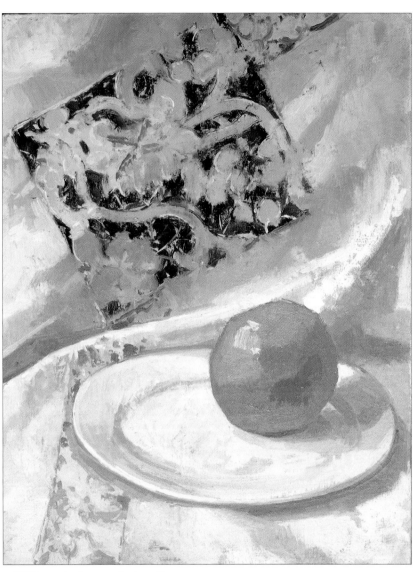

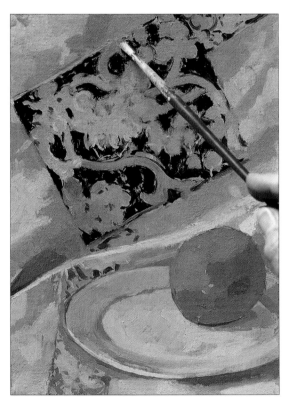

6 *The artist has worked on fine canvas stretched over board and lightly tinted with a wash of watercolour. He finds that a coloured ground makes it easier to judge the tones of his mixtures, and in a subject such as this, with a predominance of light tones, it is particularly helpful.*

5 *The orange and the plate have been solidly built up and final touches are now given to the background. The tonal contrasts here must not be too strong, so the white is mixed with a little yellow and red to darken and warm it.*

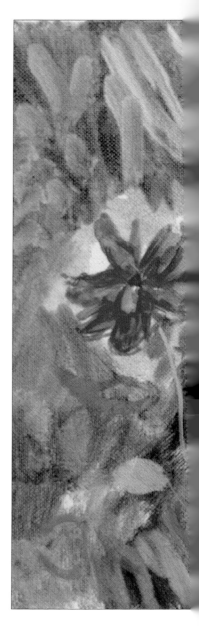

Students often want to know how to build up an oil painting – where should they start and what are the stages? These are not easy questions to answer, as there are so many different ways of doing things. Oil-painting techniques have changed through the centuries; besides which, individual artists have their own methods.

A REVOLUTION IN TECHNIQUE

The most important change in technique was brought about by the French Impressionists in the 19th century, who overturned many earlier ideas, not only about methods but also about the whole nature of art. Previously, oil paintings had been built up in layers, beginning with a monochrome underpainting on a mid-toned ground. This established the composition, the modelling of forms and the whole tonal structure of the work. The colour was added only as a final stage. These paintings were done in the studio, with location work restricted to small studies.

The Impressionists worked out of doors direct from their subject, abandoning the complex layering method entirely and always completing a painting in one session. This method, known as working "alla prima", which means "at first", rapidly became the norm, particularly for outdoor work, where speed is vital. However, many of the older methods are now being revived in modified forms and some artists prefer to work over an underpainting, a method which is discussed on the following pages.

WET INTO WET

The term "alla prima" does not describe one specific technique because there are different ways of starting and completing a painting in one go. There is, however, one feature that characterizes alla prima paintings: that of blending colours wet into wet. When paint is allowed to dry before further layers are added, each new brushstroke is crisp and well-defined, but laying one colour over and into still-wet

Working wet into wet

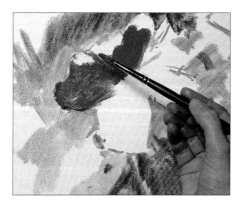

1 *Working in oil on canvas board, the artist begins with the paint used thinly, diluted with turpentine alone. White spirit can also be used, but turpentine, being slightly oily, gives a more lustrous surface.*

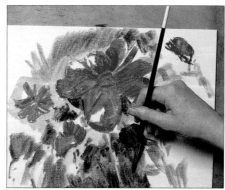

2 *Having blocked in the flowers, still with fairly thin paint, she blends dark green into the still-wet paint beneath. She uses a sable rather than a bristle brush, as this makes a softer impression.*

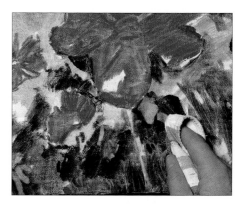

3 *A soft, blurred highlight is now created by wiping into the paint with a rag. The first layer of blue-green, which is now dry, remains in place.*

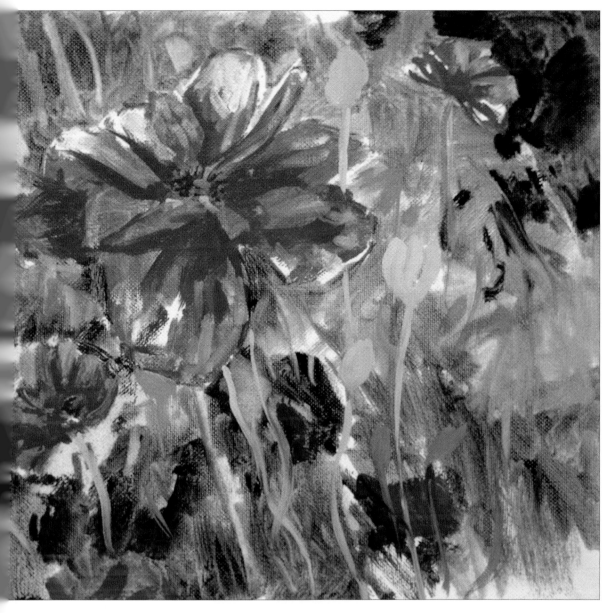

6 (Left) *In any oil painting, but particularly for wet-into-wet methods, it is best to begin with thin paint and build up gradually to thicker applications, otherwise the paint becomes unmanageable. Here the thickest colour has been used for the red flowers.*

4 (Right) *The paint is now used more thickly, slightly diluted with a mixture of linseed oil and turpentine, and the brushstrokes are gently blended into one another.*

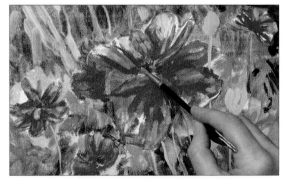

5 (Right) *White is applied lightly over the wet red paint so that the two colours mix together on the surface, to produce a gentle pink highlight.*

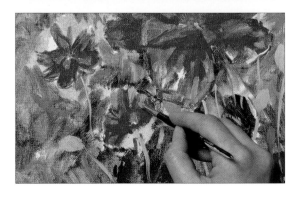

paint creates a gentler, less decisive effect, as each new colour is modified by the one below. The Impressionists painted wet into wet extensively – the soft, slightly blurred effects you see in Monet's beautiful paintings of water and foliage were achieved in this way.

The method is not quite as easy as it sounds; you need a light touch and it's best to avoid too much overworking. Too many colours laid one over another can result in a churned-up mess of paint, with no colour or definition. If this happens, scrape the area back with a palette knife and start again. It is only possible to work wet into wet in acrylic if you use a made-for-the-purpose retarding medium to keep the paint moist and workable.

UNDERPAINTING

Most artists make a drawing on their working surface before they begin to paint; this can be a brush drawing or one made with pencil or charcoal. Some take this framework for the painting one step further, making a full-scale underpainting in monochrome. This allows them to plan the composition and the tonal structure of the picture before putting on the colour.

A monochrome underpainting need not be in shades of grey – monochrome simply means one colour. Another function of the underpainting is to provide contrasts of colour; sometimes areas of underpainting are left to show through in the finished work, or the paint is applied thinly enough to be modified by the colour of the underpainting – a method often used in conjunction with glazing techniques in either oil or acrylic. The Renaissance painters liked to use a green underpainting, building up warm skin tones with thin layers of colour. In the same way a warm red or yellow underpainting could be tried for a subject in which greens and blues predominate.

More than one colour can be used – underpainting simply means a layer of paint below the top layer. Some artists begin their paintings by covering the whole canvas with "washes" of very thin paint, heavily diluted with turpentine; they allow this to dry and then build up gradually to thicker paint. Because oil paints can be used over acrylic (but not vice versa), acrylic is sometimes used for the earlier stages of paintings built up in this way, although oil paint thinned with turpentine also dries quite quickly.

Underpainting in acrylic

1 *The artist begins with thin washes of diluted grey-green acrylic, gradually building up the basic forms of the face and head. She is working on canvas board.*

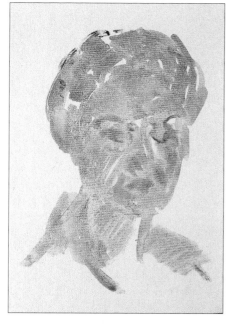

2 *The underpainting is now complete, providing a tonal basis on which the colours can be applied. Although working in acrylic, she uses the traditional method of beginning with thin paint.*

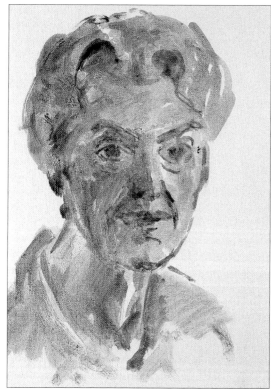

3 *She now turns to oil paint, still using it thinly for the hair and then slightly more thickly for the warm colour of the forehead.*

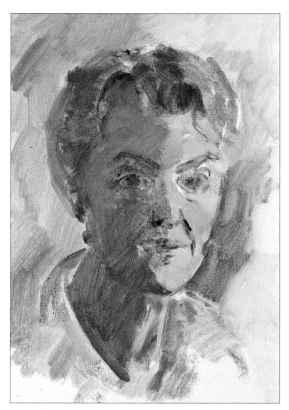

4 *The colour used for the forehead has been blended lightly into the underpainting to give a soft gradation of tone. The mauve-blues of the background have been kept thin by diluting the oil paint with turpentine.*

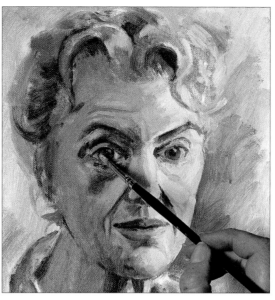

5 *The oil paint is thicker for the highlights and details of the features, but in places the underpainting is still visible; you can see the original grey-green on the hair and beneath the left eye.*

6 (Below) *The colour chosen for the underpainting depends on the effect you want to achieve. This dull green is a traditional choice for portraits and figure work, as it helps to establish a contrast between shadow areas and warmer highlights.*

FROM LEAN TO FAT

Nowadays there are few hard-and-fast rules in oil painting but, if you are building up a painting in layers, you must always work from "lean" to "fat", or from thin paint to thick. When diluted (lean) paint is laid over thick, oily (fat) paint, cracking may occur due to the top layer drying before the bottom one, which shrinks slightly as it dries. Apart from these technical considerations, saving the thick paint until last also minimizes the risk of churning it up by subsequent painting over the top.

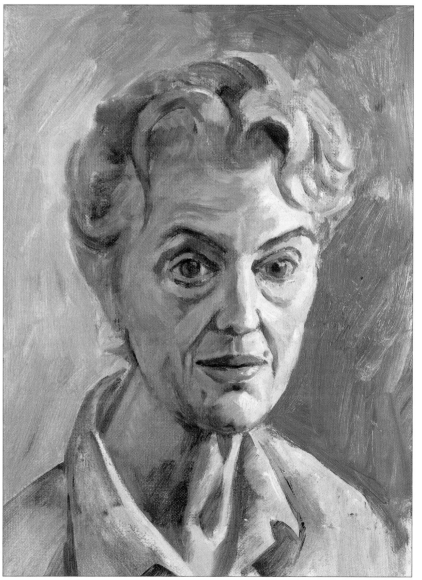

WORKING ON A TINTED GROUND

O
I
L

&

A
C
R
Y
L
I
C

Up until the middle of the 19th century it was standard oil-painting practice to work on canvas which had been given an overall tint, called an *imprimatura*. The Impressionists abandoned this practice, as they did so many others, and worked on white canvas, which they found increased the brilliance of the colours (though Monet returned to coloured grounds at various stages in his career).

Today's artists are divided on this issue, but there is no doubt that a coloured ground can be very helpful. White is an artificial colour (there is little or no true white in nature) so beginning with a white surface makes it difficult to judge the strength of the first colours you apply. You may make them too light, because any colour looks dark against white. Colouring the canvas provides an average tone, allowing you to work up to the lightest areas and down to the dark ones.

The choice of colour will influence your painting from the start. The most usual choices are neutrals such as browns, yellow-browns, greys and blue-greys. These are useful base shades on which to apply brighter colours. Some artists like a ground which contrasts with the overall colour scheme, for example warm brown for a painting in which blues will predominate; others prefer one which harmonizes. In either case, small areas of the ground colour are sometimes allowed to show through between brushstrokes, which has the effect of pulling the picture together, or unifying it, by creating a series of colour links. In this way a coloured ground can act very much like an underpainting.

Laying a ground is very easy and you can use either acrylic, watercolour or oil paint thinned with white spirit – obviously one of the first two if you are working in acrylic. Spread the paint over the surface either with a large brush or with a rag. It doesn't matter if you create an uneven, streaky effect; a completely flat colour tends to look mechanical and unappealing.

Acrylic on a blue ground

1 *The ground colour chosen for oil paintings is most frequently an unobtrusive brown or grey, but acrylic encourages a bolder approach; a deep blue is used here. The artist, working on watercolour paper, applies the ground with a large nylon brush for quick coverage of the surface.*

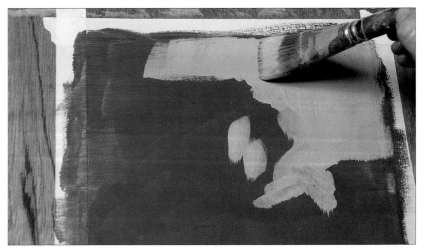

2 *She begins with the light area of sky, painting boldly with another large, square-ended nylon brush. The paint is used quite thickly, mixed with just enough water to make it malleable. She has not made a preliminary drawing because acrylic can easily be corrected by overpainting.*

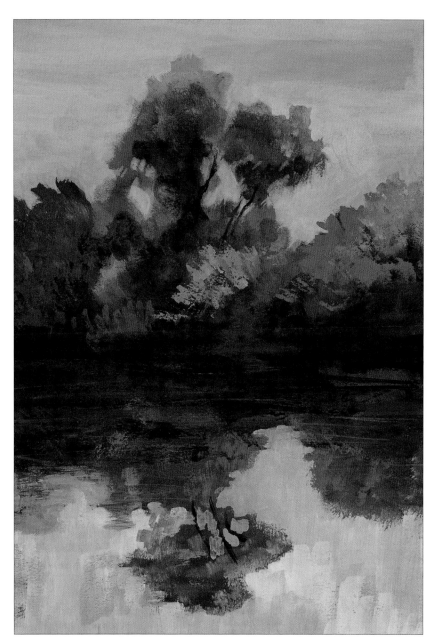

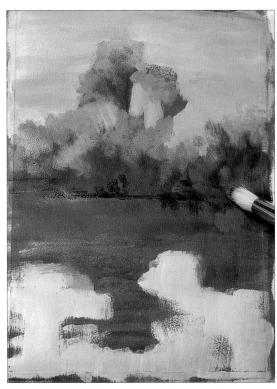

3 *Dark green is now painted over the blue, this time using a smaller bristle brush to make dabbing brushstrokes which do not completely cover the blue ground colour. The paint is also used quite thinly to modify the blue without obscuring it.*

6 (Above) *The dark reflections beneath were slightly blurred by glazing over them with well-watered paint, applied with a large, soft brush.*

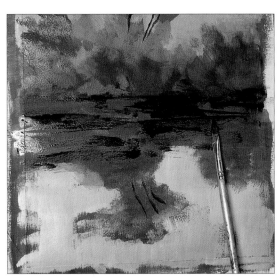

4 *To create the blurred effect of the water, black paint is lightly scrubbed over the underlying colours, which are now dry. Again, care is taken not to cover all of the blue underpainting.*

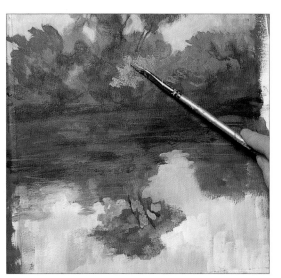

5 *In the final stages, a definite centre of interest is created by introducing a vivid yellow-green into the small tree.*

BRUSHWORK

O
I
L

&

A
C
R
Y
L
I
C

As the natural consistency of both oil and acrylic paints is thick and creamy, they hold the marks of the brush very well and, for any paintings except those built up in smooth layers or glazes, brushwork is an integral part of the painting. The idea of exploiting the physical presence of the paint began with artists such as Titian in the 16th century and Rembrandt in the 17th; it was developed further by the Impressionists and further still by Cézanne and Van Gogh – the two artists one automatically associates with brushwork.

Many promising paintings are spoiled by inattention to brushwork. This is understandable when there are so many other things to consider, such as working out how to mix the colours, getting the drawing right, and the general business of depicting your subject. But brushwork needs as much consideration as any other aspect of the painting; in fact, it can help you in the task of description. If you are painting a tree trunk, for example, or you want to suggest the sweep of a hill or field, it is easier to use a large brush and let it do the work by following the forms and directions than it is to build up the shape with a series of small, fussy strokes.

One thing you need to guard against is inconsistency of brushwork. Your brushstrokes do not all have to go in the same direction or be the same size (though they can be), but you must use the same approach throughout. If the sky in a landscape is painted flatly, and bold, sweeping brushstrokes are used to depict trees and hills, the picture looks disjointed. Skies can be problematic because they do appear flat, but here you must use artistic licence. Paintings by Cézanne clearly reveal individual brushmarks in the sky area as well as a variety of different colours.

Exploiting the brushmarks

1 *Working in oil on oil-sketching paper, the artist uses her bristle brush as a drawing implement, making sweeping strokes to describe the shapes of the hills.*

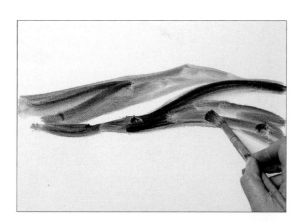

2 *It is not necessary to use thick paint to exploit brushmarks, and here it is quite thin (it has been diluted with turpentine). This gives the brushstrokes an uneven striated quality, with the white paper showing through in some areas.*

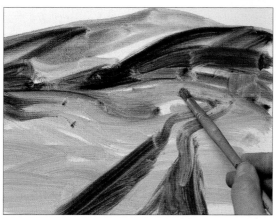

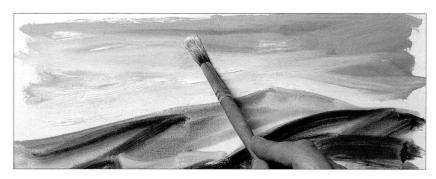

Brushes are made in different shapes as well as different sizes, and it is worth experimenting with them to discover the kinds of mark they can make. Cézanne used mainly large flat brushes, which give a brick-like stroke, whereas Monet favoured pointed ones, applying the paint in smaller dabs. Try out all your brushes, holding them in different ways and varying the pressure to make different kinds of strokes. This kind of doodling will help you to discover your own painting style.

3 (Above) *The paint is used more thickly here, but the brushwork is similar to that depicting the land area. The artist uses long, sweeping strokes, letting the brushmarks follow the direction of the hills.*

4 *The paint was used thinly in the early stages and the first applications are now dry; consequently, brushstrokes of thicker paint can be laid without disturbing those below.*

5 *The brush is used in a different direction, with more upward strokes, again of thicker paint, suggesting the stone wall in the middle distance without describing it literally.*

6 (Below) *The brushwork is consistent throughout the painting, and not only describes the forms of the landscape but also imparts movement and energy to the picture.*

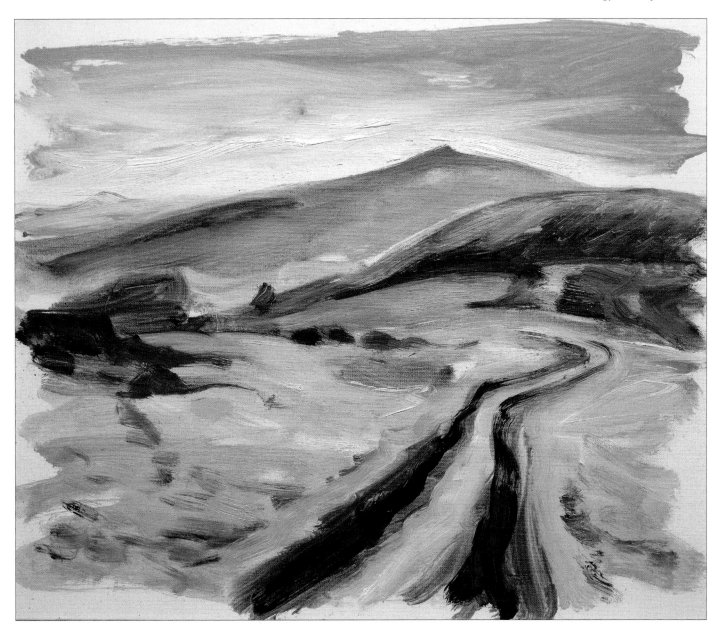

IMPASTO

Impasto means thicker-than-usual paint. For some artists, one of the main attractions of oil and acrylic is that they can be built up thickly to create a range of exciting surface textures.

Impasto techniques are far from new. Both Rembrandt and the great 19th-century landscape painter, J.M.W. Turner, used thick, solid paint in some areas of their paintings, contrasting this with thinner applications elsewhere. In some of Rembrandt's portraits, too, the faces, particularly the highlight areas, are so solidly built up that they resemble a relief sculpture. Van Gogh was the first artist to use uniformly thick paint, applied in swirling or jagged brushstrokes; since then many artists have exploited the expressive and dynamic qualities of thick paint, sometimes squeezing it on straight from the tube and then modelling it with a brush, or applying it with a knife or even fingers.

Impasto of this nature requires a great deal of paint, so it is a good idea to bulk it out with one of the special media sold for impasto work in both oil and acrylic. This is particularly necessary for acrylic, as it is slightly runnier than oil. The media are effective, enabling you to produce two or three times the amount of paint without changing the colour. The only other way to bulk up paint is to add white.

Impasto used selectively, for specific areas of the painting, is usually reserved for finishing touches, highlights or any small areas of vivid colour in the foreground. There is a good reason for this: thick paint, having a more powerful physical presence than thin paint, tends to advance to the front of the picture.

Using thickened paint

1 *This photograph shows the oil paint being mixed with special impasto medium (the brownish substance on the left). Similar mediums are available for working in acrylic.*

2 *Sometimes impasto is reserved for certain areas of a painting, usually added in the final stages, but here thick paint is used throughout. At this stage, each area of colour is kept separate to avoid mixing and muddying.*

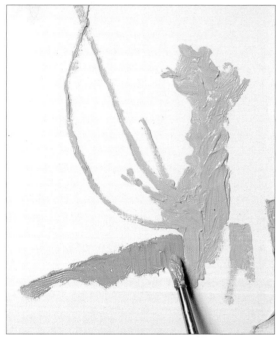

3 *In this sky area, the brush is taken in different directions, creating ridges and swirls of paint which reflect the light in varying degrees.*

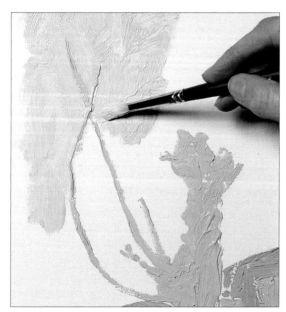

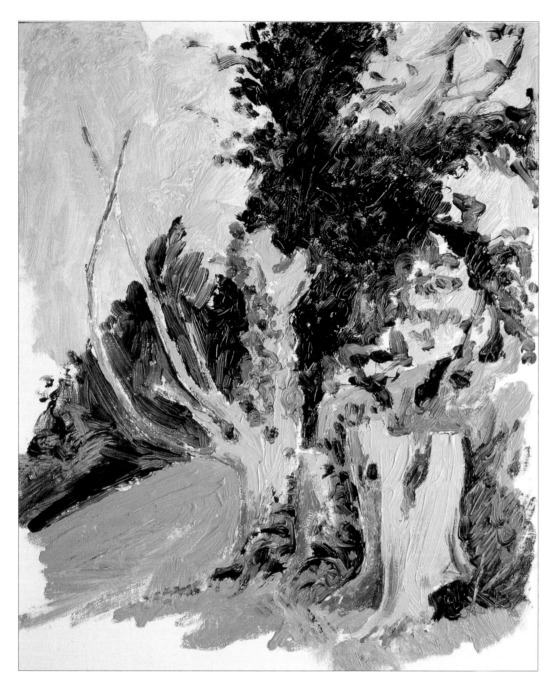

6 (Left) *Finally, with deft touches made with the tip of the brush, darker colours were laid over and into the light yellow-browns on the tree trunks. Paint applied as thickly as this takes several days to dry out thoroughly.*

5 (Right) *To produce a soft blend of colours, dark green is worked into a lighter one, wet into wet. The top and edges of the dark green foliage have also been softened by painting over the light grey of the sky.*

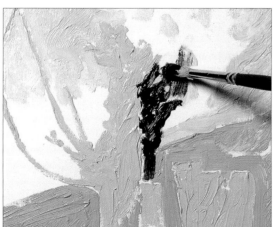

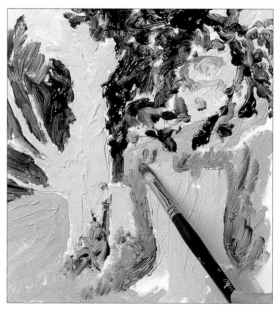

4 *Again, the artist takes care to keep each new colour separate. If the thick dark green paint were allowed to mix with the lighter colour, both would become muddied.*

KNIFE PAINTING

A brush is the most obvious implement for applying paint, and the most commonly used, but paint can also be put on with a knife made for the purpose. Knife painting is an exciting and expressive technique, and it creates effects quite different from any which can be achieved with a brush. The knife squeezes and flattens the paint on the surface, producing a smooth plane with ridges at the edges.

These small ridges and lines of thicker paint catch the light and, when a whole painting is built up with knife marks, they create an energetic and lively effect. Like brushstrokes, the marks can be varied according to their direction, their size, the amount of pressure you apply and the thickness of the paint. But take care not to overwork; too many knife strokes laid over one another will sacrifice the crispness which characterizes the method, creating a muddled impression.

Like any other impasto technique, knife painting can be used selectively to emphasize certain areas of the painting. For a floral subject, you might use a flick of the knife to suggest a highlight on the vase or a leaf catching the light, while in landscape you could enliven a dull foreground with some fine strokes made with the side of the knife, depicting long stems of grass, or make small dabs with the point of a knife to create colourful flowerheads.

Painting knives are surprisingly delicate and sensitive instruments. They are not to be confused with the ordinary straight-bladed palette knife used for general cleaning up. These knives are specially made for the job; they have cranked handles and highly flexible forged-steel blades, and are produced in a wide variety of different shapes and sizes.

Knife-painted flowers

1 *To provide a background for the colours of the flowers and leaves, the artist has begun with thin "washes" of oil paint, which she has allowed to dry before putting on the first knife strokes.*

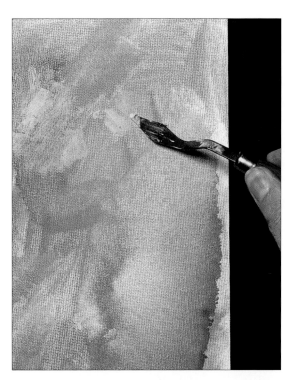

2 *Using the point of the knife, she now flicks on thick, dark colour for the stems. The flowers are still essentially a thin veil of colour, achieved by laying on paint and then scraping it back with the side of the knife.*

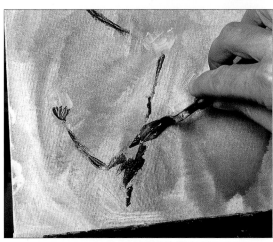

3 *A light blue-green is laid over the darker colour with the flat of the knife. Notice how this flattens and pushes the paint so that it is thinner in the centre of the stroke, only lightly covering the canvas.*

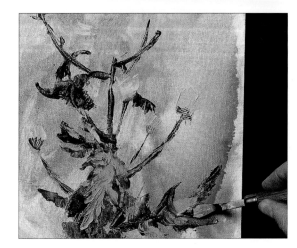

4 (Right) *The flowers are built up with a combination of strokes using the point and side of the knife. This small triangular knife is ideal for chrysanthemums and similar flowers, as each petal can be quickly created with a single sharp flick.*

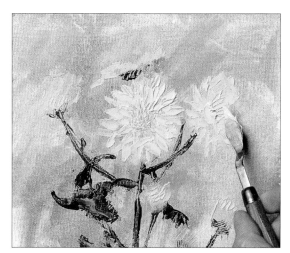 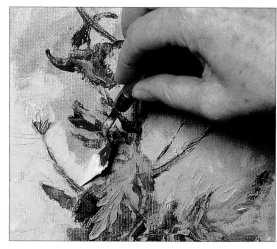

5 (Above) *Grey-green background colour is now "cut in" around the stems and leaves with the flat of the knife. If the flowers and leaves had been painted over thick, wet background paint, the colours would have mixed together and lost their brightness.*

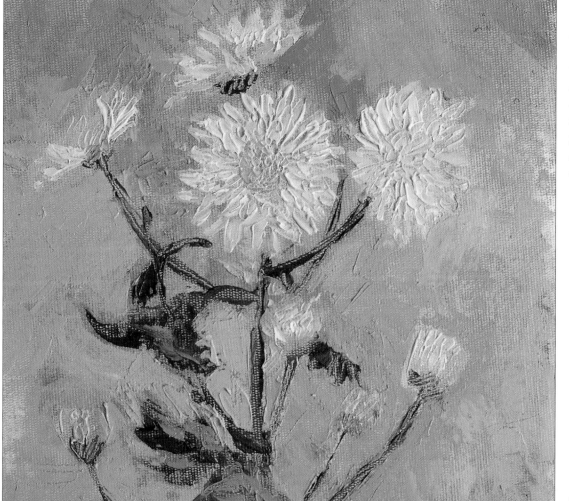

6 (Left) *The flowers and leaves are convincingly depicted, and the liveliness of the picture is increased by the contrast between thick and thin paint. The knife work stands out from the surface, while in some areas of the background the canvas is only lightly stained with colour.*

Techniques
GLAZING

Glazing is one of the traditional techniques that is regaining popularity – and for good reason, as it can create beautiful effects. The painters of the early Renaissance used oil paints very thinly, building up layers of transparent colour. The brilliant blues and reds you see in the gowns of madonnas and saints were achieved by this method.

Glazing used to be a slow process because each layer had to dry before the next one was applied, so when alla prima painting became the most usual way of working, glazing was largely abandoned. Now, however, the paint manufacturers have brought out special glazing media which cut down the drying time of oil and make the colours more transparent.

In acrylic, glazing takes no time at all because the paints dry so fast, and so the method is particularly popular with acrylic painters. The paint can be thinned with water, or with acrylic medium (matt or gloss). The latter is usually preferable, as paint thinned with water alone dries to a dull, matt finish, while the medium gives it a slight or high gloss – depending on which one you use – which enriches the colours.

Glazes can also be laid over thick paint, as long as it is dry. In acrylic particularly, thick impastos made with a brush or knife are often modified by glazes, which give a touch of delicacy to the heavy surface. This is also a good way to suggest texture, because the colours settle into the crevices.

If you intend to experiment with glazing you may have to consider buying some extra colours. Although both oil and acrylic are technically opaque, some pigments are relatively transparent. As the essence of glazing is the way one layer of colour shows through another, the best results are achieved by sticking to the more transparent colours.

Building up colours

Instead of using full-strength opaque colour from the start, it is possible to build up with a series of glazes. The "swatches" shown here are in acrylic, but similar effects can be achieved in oil, or oil can be glazed over acrylic.

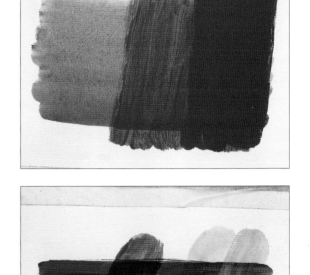

Changing colours

One colour glazed over another produces a third colour by modifying the one below. Here the top colours have been thinned with acrylic medium, which makes them more transparent.

Toning down

If colours appear too bright in one area of a painting they can be neutralized by laying a light glaze of acrylic diluted with water. Water glazes cannot, of course, be used in oil painting, but oil paint can be thinned with glazing medium.

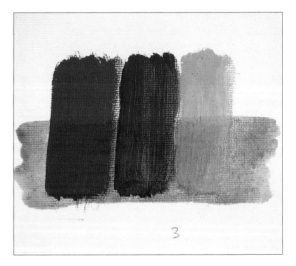

Glazing over monochrome

In either oil or acrylic, a picture can be started in monochrome – black and white or shades of one colour – and glazes subsequently laid on top.

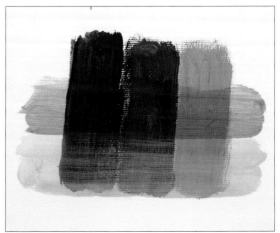

BROKEN COLOUR

When you drag oil or acrylic paint lightly over a textured canvas or a layer of dry paint, it adheres only to the peaks, thus breaking up the brushstroke and allowing some of the earlier colour to remain visible. This method, called dry brush, is particularly suitable for creating veils of colour or for suggesting texture. It is frequently employed in landscape, for example, for light on water, distant trees or the texture of grass, while in portraiture it is useful for hair and textured clothing. The trick is to apply the minimum of paint to the brush and to use a fairly thick, dry mixture.

A similar method, scumbling, gives you less control and is more suitable for large areas than for fine detail. It involves scrubbing thick, dry paint over another colour, either with a rag, a stiff bristle brush or even your fingers. You can scumble dark colours over light, but light over dark usually achieves the best results. You might use the method for skies in a landscape (scumbling light blue over deep blue to produce a shimmering effect), or for richly coloured fabric in a portrait or still life.

The effects of these methods are sometimes described as "broken colour" – a term which has an alternative meaning, referring to an area built up with small brushstrokes of separate colours. This technique was more or less invented by the Impressionists, who found that they could make areas of grass or foliage appear brighter by juxtaposing blues, yellows, greens and sometimes purples, which from a distance would be interpreted as green.

4 (Right) *As well as being the ideal method for suggesting texture, dry brush also creates a livelier effect than flat areas of colour. It is best to work on a textured surface – this picture has been done on canvas board.*

Dry brush in acrylic

1 *The artist has begun with an underpainting of rich blue-green for the land, with transparent washes for the sky. She now drags thick paint lightly over.*

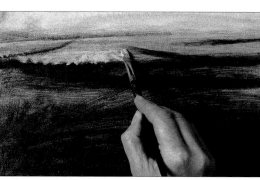

2 *For the foreground she uses the same brush but makes shorter, more upright strokes, varying them to suggest both the texture and movement of the grass.*

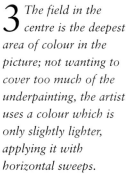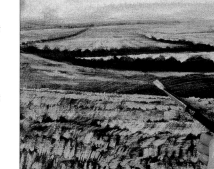

3 *The field in the centre is the deepest area of colour in the picture; not wanting to cover too much of the underpainting, the artist uses a colour which is only slightly lighter, applying it with horizontal sweeps.*

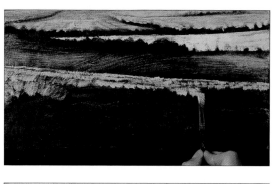

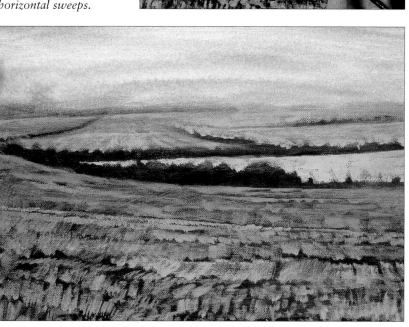

REMOVING PAINT

The first two methods described here are not suitable for acrylic, as they rely on the slow-drying nature of oil paints.

SCRAPING BACK

When something goes wrong with an oil painting, you can scrape back the offending area or even the whole painting with a palette knife – as long as the paint is still wet – and repaint it. If you have ever done this, you may have noticed that the effect of the scraped painting is rather attractive – a misty ghost image of the original picture.

Scraping back need not be limited to correcting mistakes; it can be a technique in its own right. It has been employed by several well-known artists, most notably the 19th-century American-born artist James Whistler, who often scraped back his portraits at the end of each day's session in order to avoid overworking his paint and, on one occasion, observed that this gave him exactly the effect he wanted for the gauzy dress of his young girl sitter.

Scraping back is a layering technique, similar in some ways to glazing, as each new application of colour, after scraping, reveals something of the colours below. You can use it to build up subtle colour effects, or to create the impression of a misty landscape. If you work on a textured surface such as canvas or canvas board, the knife removes the colour only from the top of the raised grain, leaving a deposit of paint in between the weave.

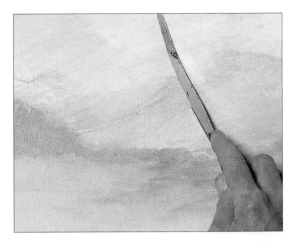

1 *Working on canvas board – stretched canvas could be damaged by scraping – the artist lays thick paint on the sky and hills and scrapes over it with the side of a palette knife.*

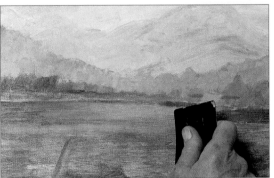

2 *Having begun with a wash of yellow-green which has now dried, she then laid darker, thicker colour which she partially scrapes away. This time she uses a plastic credit card, a useful if unusual painting tool.*

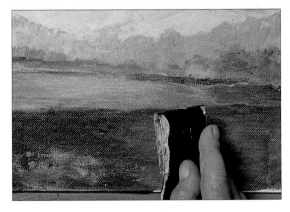

3 *The foreground has been darkened with successive applications of paint, each subsequently scraped back. The artist now used the card first to apply paint and then to scrape it back in diagonal strokes.*

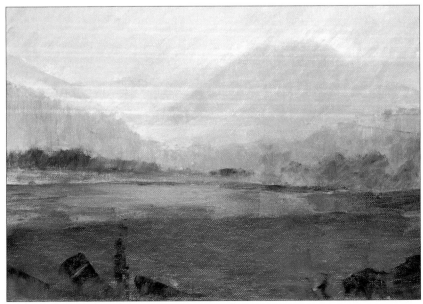

4 (Right) *The technique is particularly useful for atmospheric effects and subtle blends of colour. Finger smudging has been used in places, and the shapes in the foreground were made by using the plastic card as a painting knife.*

Scratching into paint

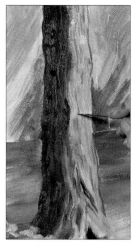

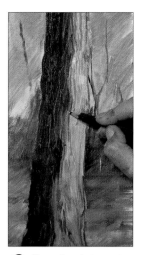

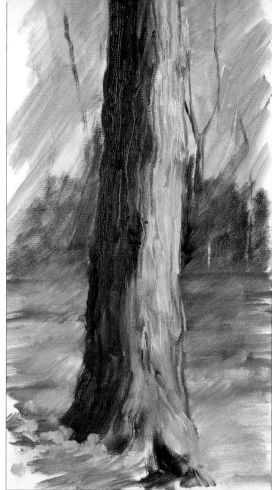

1 *Having laid a foundation of relatively thick oil paint on canvas board, a paintbrush handle is used to draw into it, creating ridges and indentations.*

2 *The point of a scalpel removes the paint more cleanly and thoroughly, revealing the surface of the canvas beneath in a series of fine white lines.*

3 *Drawing into wet paint with a pencil is a variation of sgraffito. The pencil makes dark lines as well as similar indentations to thoses produced by the paintbrush handle.*

4 *(Above) This method is useful for textures and ideal for making the kind of very fine lines which are difficult to achieve with a paintbrush, such as stalks of grass or tiny twigs catching the light.*

SGRAFFITO

This involves scoring or scribbling into the paint while it is still wet – the word comes from the Italian *sgraffiare,* to scratch. Rembrandt used to scribble into thick, wet paint with a brush handle to suggest the hairs of a moustache or the pattern and texture of clothing. Working into thick paint in this way produces an indented furrow, with slight ridges where the paint has been pushed upwards. This can be a useful method for describing textures.

Sgraffito can also be used in a purely decorative way to add a pattern element to your work. If the top application of paint is thin, you can scratch into it with a sharp implement to reveal the white of the canvas, or another dry colour below. For example, the objects in a still life could be outlined with fine white lines or you could create the pattern on a piece of fabric by scratching back to another colour. Although sgraffito is easier in oil, it can be done with acrylic too, as it is possible to scratch into dry paint providing you work on a rigid surface such as a painting board.

TONKING

Invented by Sir Henry Tonks, one-time professor at the Slade School of Art in London, tonking is another correction method which can be utilized as a technique. An oil painting often reaches a stage where it is unworkable because there is such a heavy build-up of paint that any new colours simply mingle with the earlier ones, producing a muddy, churned-up mess. Tonks recommended removing the top layer of paint by laying a sheet of newspaper over the painting and rubbing gently to transfer the paint to the paper. The resulting softened image can be a basis for further work, but often the effect is pleasing in itself; you can leave the tonked painting alone, or perhaps add touches of further definition in certain areas. Tonking is particularly useful for any painting in which you have tried to add too much detail too early on, such as a portrait, where the eyes and mouth tend to attract a concentration of paint.

COMPARATIVE DEMONSTRATION

Oil and acrylic paints can be used in many different ways. One of the best ways of learning, at least initially, is to attempt to emulate the methods of artists whose work you admire. In order to provide a stimulus as well as to show something of the possible variations in approach, we have asked three artists to paint the same still life subject. James Horton is working in oil, on fine canvas stretched over board, primed with whiting and rabbit-skin glue and tinted with watercolour, giving a slightly absorbent and lightly coloured surface. Patrick Cullen is also working in oil, but on white canvas board. Rosalind Cuthbert is painting in acrylic on paper, making considerable use of glazing methods.

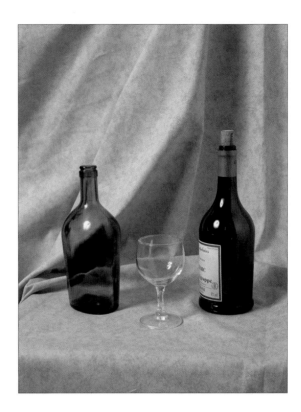

Oil on primed and tinted canvas

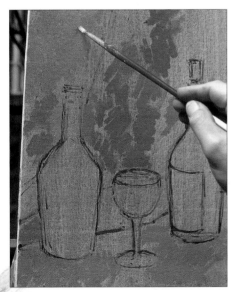

1 *The artist has begun with a brush drawing (in a mixture of Venetian red and raw umber) to establish the shapes and position of the bottles, and now works on the warm colours of the background. It is important to have some of this colour in place before painting the bottles.*

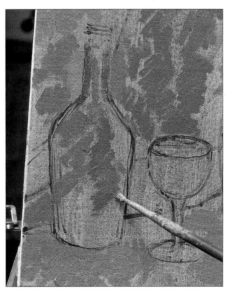

2 *His method is to place small patches of colour all over the picture surface in order to assess the relationships of colour and tone at every stage in the painting.*

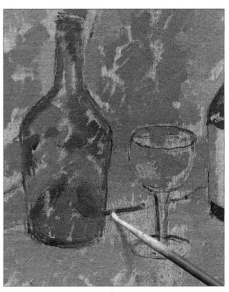

3 *Darker tones have now been introduced into the bottles, and he returns to work on the background, using a lighter colour to bring out the dark greens.*

(Right) Various artists' palettes give an interesting insight into their various working methods. In this case the "brushstrokes" used to mix the colours reflect those in the painting itself.

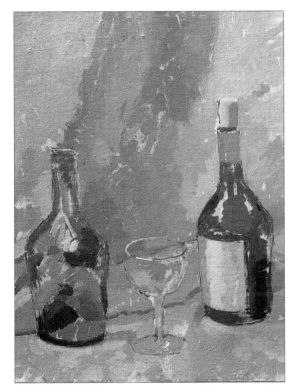

4 *With the painting at about the halfway stage, the brushwork is still loose, with the surface not yet fully covered. The paint is used at the same consistency throughout, slightly thinned with a mixture of turpentine, linseed oil and Damar varnish.*

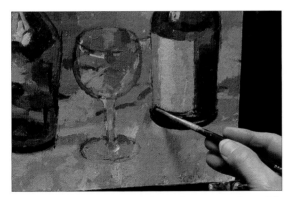

5 *Ellipses are always tricky and, in spite of careful initial drawing, have to be maintained through the course of the painting. Here the edge of the label is defined by cutting in darker paint around the bottom.*

6 *(Right) In the final stages, details were added, such as the suggestion of printing on the label, the cork of the bottle and the ellipse of the glass. Notice how varied the brushwork is, and the many different colours used in each area of the picture.*

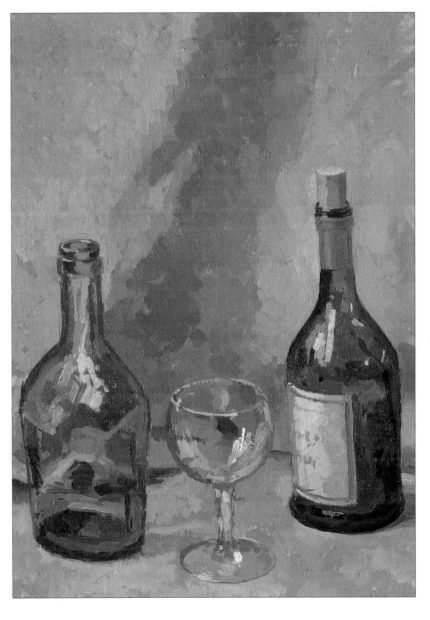

Continued ▷

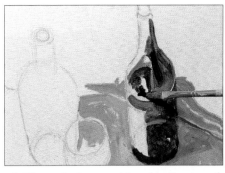

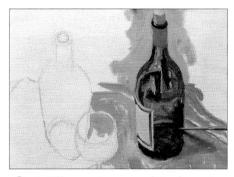

1 The artist began with a drawing in soft pencil, erasing from time to time until it was correct. He uses the paint quite thinly, diluting it with a 50:50 mixture of synthetic medium and turpentine.

2 A difference in approach in the early stages is immediately apparent. This artist takes each part of the painting close to completion before beginning on the next; here he works extensively on the bottle.

The artist prefers a large kidney-shaped palette to the small rectangular type which fits into the lid of a paintbox. Once more, the brushwork in the painting is echoed in the palette.

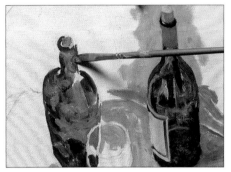

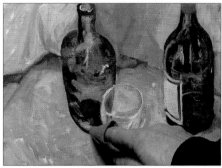

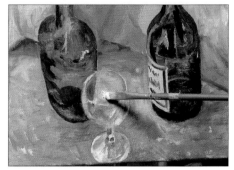

3 The first bottle is now virtually finished, and the second one is painted before the background. The white board shows through the thin paint in places to suggest the transparency of the glass.

4 With the background and the wine glass now painted, finishing touches are given to the bottle. A soft highlight is created by rubbing into the wet paint with a clean rag.

5 When painting transparent objects it is vital to ensure the continuity of the background, so this has been painted first, leaving the highlights and shadows of the glass until last.

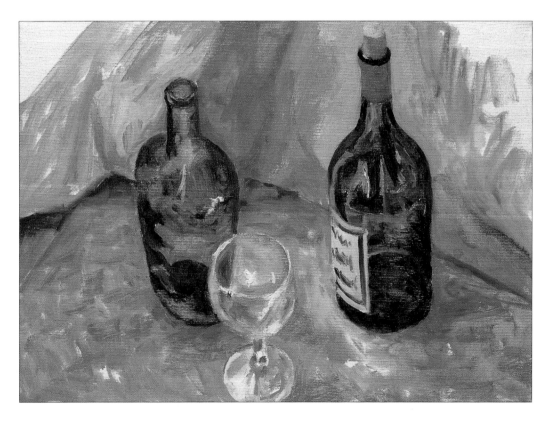

6 The biggest difference between this and the previous painting is in the consistency of paint, which here has been wiped off to create highlights rather than added as thicker paint. The brushwork in both paintings is lively and varied, but each artist has a distinctive style.

Acrylic on watercolour paper

1 The artist begins with a thin under-painting diluted with water, lightly sketching in the shapes of the bottles. She seldom makes an initial drawing when using opaque paints.

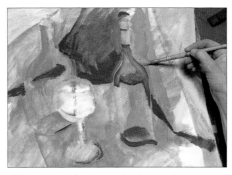

2 Her method is to build up the more subtle colours by glazing in successive layers over a brightly coloured base, so initially she uses blue for the bottles and a rich red for the background.

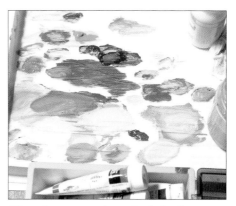

These Stay-Wet palettes look far from attractive after a day's work, but they are ideal for preventing acrylic paint from drying out.

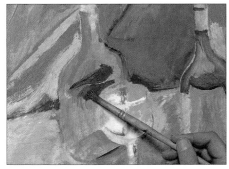

3 Paint mixed with matt medium is laid over the blue. While still wet the colour looks opaque, but it becomes more transparent as the medium dries.

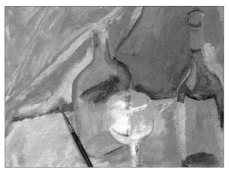

4 On the left-hand bottle you can see the effect of the glazing method clearly – the paint has now dried and each colour shows through the other. Slightly thicker paint is now used for the background.

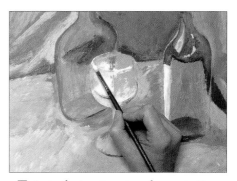

5 As in the previous two demonstrations, the glass is left until last. The highlights on the ellipse are painted, again with a fine sable brush, but this time with thicker paint, straight from the tube.

6 This artist has taken a less literal and more personal approach to the group than the other two, inventing a blue 1background and keying up the colours. She has also deliberately distorted the right-hand bottle to improve the composition.

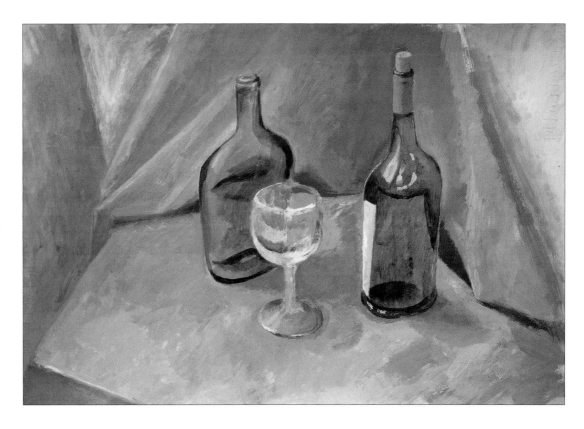

STILL LIFE

Throughout the history of painting, still life has gone in and out of fashion, mainly according to the whims of buyers. Still-life paintings were particularly sought after in 16th- and 17th-century Holland, while in France and England they were less popular nationally, although there were certain areas where this branch of painting flourished. In the 19th century, when more humble, down-to-earth subject matters began to replace grandiose historical works, still life came into its own; since that time many artists have painted still life in addition to other subjects, and some have made it their speciality.

There is no better way of practising your skills and working out ideas about colour and composition than by choosing and arranging your own subject. When you are painting landscape on the spot, the arrangement of shapes and colours is dictated by nature, but with still life you are the one in control – you have a captive subject. You can set up the group in any way you choose, decide on the best lighting and take as long as you like over the

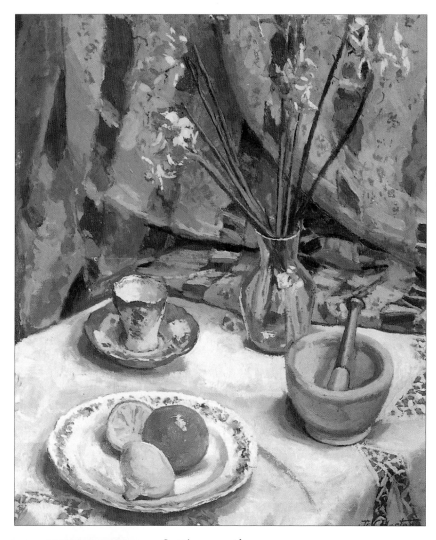

Setting up the group

(Above) *In still-life painting, much of the composition is done before you begin to lay paint on paper, so it is wise to take time at this stage. In James Horton's oil painting* Still Life with Narcissi *the objects, the tablecloth and the background drapery have been arranged with great care. By overlapping the mortar and the flower vase, a link is established between them, while the pattern on the tablecloth draws the eye into the composition.*

Repeating colours

(Left) *Elizabeth Moore's lovely* Objects on a Table *(oil) is also carefully arranged, although she has aimed at a more natural-looking effect. When painting a wide assortment of objects, some unifying factor is needed, and here she has created relationships of colour by taking the mauve-blues through the painting.*

Pattern and viewpoint

(Right) *The viewpoint you choose for your still life depends on your personal approach and interests. Seen from above, objects become flattened to some extent, creating a clearer pattern than at eye level. In* Still Life with Aubergines *(oil) Robert Maxwell Wood has exploited this element to the full, choosing and arranging the objects so that they echo the bold motifs of the fabric – notice the pansy, which appears both as living flower and as printed pattern.*

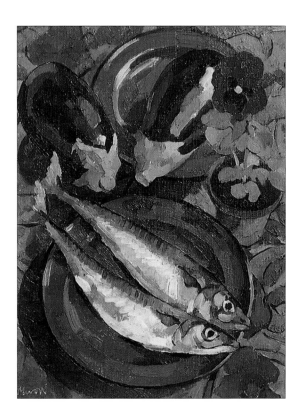

Composing with light

(Below right) *Light and shadow can play a vital role in any still life illuminated by natural light, and in* Lilies and Straw Hat *(oil) by Timothy Easton the shapes made by the shadow of the window bars and flowers are as important as the objects themselves. The use of carefully controlled, pale colours, with the only dark tone being the foliage glimpsed through the window, beautifully expresses the theme of light, which is further illustrated by the hat in the foreground – sunlight by association.*

CHOOSING A THEME

Most still lifes have some kind of theme, with the objects linked by association. An ill-assorted group of objects with nothing in common creates an uneasy feeling – the Surrealist painters used odd juxtapositions for this very reason. Still lifes with a culinary theme are a common choice: for example, fruit and vegetables placed on a kitchen table.

But the theme can be simply one of colour or shape. For example, you might choose a group of predominantly blue objects, placed on a yellow or pink cloth for contrast. You might be attracted by the vertical emphasis of bottles, or long-stemmed flowers in a tall vase, or be interested in an arrangement of plates and bowls which make a series of intersecting circles and ovals.

Still lifes can also tell a story, or hint at one. Artists may choose a subject close to their hearts, or something which has associations for them, such as favourite books, or a hat worn during a successful holiday. Van Gogh, when he was working as a peasant in the fields, painted a pair of battered, work-stained boots, which spoke volumes about the desperation of his life at the time.

painting. You are not at the mercy of the weather, as you are with landscape; indeed, still life is something you can always fall back on when it is too cold, wet or dark to paint anything else.

ARRANGING THE GROUP

It must be said that still life is not an easy option. You have to take as much care over choosing and arranging the objects as you do over painting them. Cézanne, who produced some of the most beautiful still lifes in the history of art, sometimes spent days over the initial arrangement.

Try to aim at a natural-looking grouping of the objects; although still life is highly artificial, it should not look that way. Let

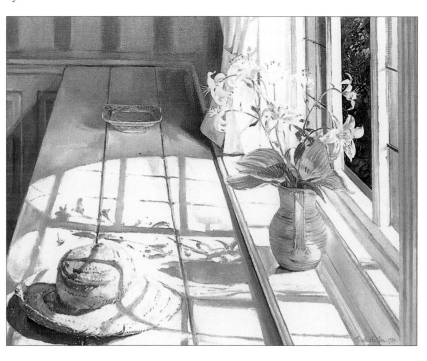

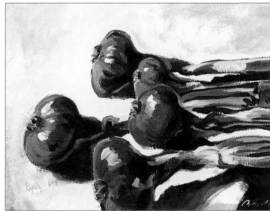

Floral still life
(Left) *The foreground can be a problem in floral groups, as the spaces beside and in front of the vase can become dull and empty if they are not filled in some way. Common devices are to introduce some other object or place one or two of the blooms in front of the vase, and in Ben Baker's colourful* Still Life with Flowers *(oil) he has done both. He has treated the foreground very broadly, however, so that the objects are mere suggestions and do not detract from the painting's centre of interest, which is emphasized by the use of a dark background.*

some of the objects overlap, but be careful how you do this. Avoid obscuring one shape with another or leaving too small a part of one showing, as this can create an awkward, cramped feeling.

Consider too the spaces between things – wide gaps between objects may make them look disconnected, in which case some kind of link needs to be established. Depending on the source of light, shadows can provide a link between objects; another well-known device is drapery, often seen in still lifes, curving round behind, between and in front of objects to unite them.

Drapery also gives a sense of movement to the group. In any good painting, whatever the subject, the composition is arranged to lead the eye from one part of the picture to another. For this reason, avoid placing objects so that they "look" out of the picture. If the spout of a teapot,

for example, is pointing outwards instead of inwards towards the other objects, the eye will naturally follow its direction.

PLANNING THE PAINTING
It often happens that a group that has taken time to set up causes problems when you start to paint, or to make your preliminary drawing. You may now notice that one object is too tall, giving you a featureless area of background on both sides of it, or that there are too many objects crowded to the front. You can always make adjustments; it is better to get things right before you have gone too far than to paint something you don't like.

Once satisfied with the arrangement, you must consider how you are going to place it on the canvas. This means deciding what angle to paint from, what viewpoint to take and how much space to leave around the

Unusual treatments
(Above) *One of the exciting aspects of still-life painting is that the objects you choose can often suggest new approaches, in terms both of composition and treatment. Gerry Baptist initially chose this bunch of onions for his acrylic painting* Red Onions *because he liked their rich colours, but their shapes suggested movement, so he has arranged them in such a way that they appear to be rushing across the paper, an effect he has played up by using strong shadows and long, sweeping brushstrokes.*

Found still life

(Below) *Although most still-life paintings are the result of planning, occasionally something makes a natural painting subject. Examples could be clothes left on a chair, shoes in the corner of a room – indeed almost anything in your home environment. In his oil painting,* Decorated Tree, *Robert Maxwell Wood studies shapes, colours and textures not normally associated with still-life painting.*

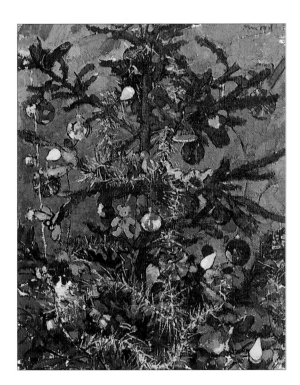

objects. If your group is on a table top and the front of the table is in the picture, it is best to avoid a straight-on view, as this creates a horizontal in the foreground. Horizontal lines give a static impression, whereas diagonals lead the eye inwards, so study the group from different angles.

It can be interesting to look down slightly on the group you are painting, particularly when circles (plates and bowls) are an important part of the theme. From a high viewpoint, you see a rounder ellipse – the term for a circle in perspective – than you do at eye level. The viewpoint you choose depends very much on what you are painting; experiment with high and low viewpoints as well as different angles. Some artists find it helpful to settle all these questions before they begin to paint by making a series of rough sketches of the group, seen in various ways.

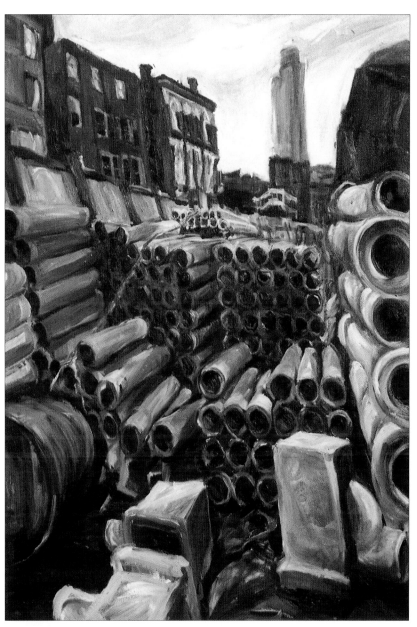

Outdoor still life

(Above) *A still life can be broadly defined as anything that is not capable of movement, so it follows that you may find ready-made groups outside as well as in your home. Stones on a beach, plant pots, a group of chairs in a garden, or glasses and bottles on a café table are just some of the many possibilities. In* East End Pipes *(oil) Karen Raney has found an exciting and unusual subject which has allowed her to explore strong contrasts of tone and relationships between shapes and colours.*

STILL-LIFE DEMONSTRATION

James Horton regards himself primarily as a landscape painter, although he also paints portraits and often turns to still life when the weather does not permit outdoor landscape work. He enjoys still-life painting because it allows him total control of the subject, enabling him to work out ideas on composition and colour. He works in oil on a small scale, painting on canvases he prepares himself by stretching cotton fabric over board. They are then primed with a home-made recipe consisting mainly of whiting and rabbit-skin size.

1 (Right) *The artist dislikes working on white canvas, so, after priming, he tints it with a wash of watercolour. He has chosen a warm yellow ground colour which will help to establish the overall colour scheme. For the initial drawing, made with a fine sable brush, he uses an equally warm red-brown.*

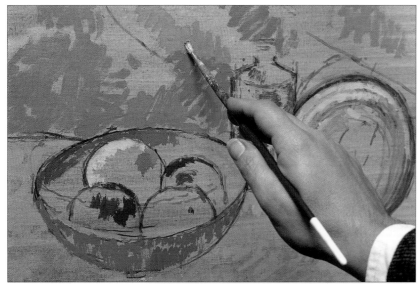

2 (Above) *He begins by placing brush-strokes over the entire picture surface, working up the foreground and background at the same time in order to relate one colour to another.*

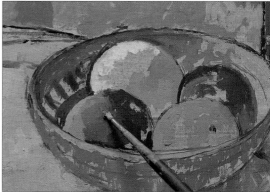

3 *Light and dark tones must be related in the same way, and the highlight of the grapefruit provides a key for judging the strength of colours needed for the apple.*

4 *Here, a painting knife is used, not to apply paint but to scrape it off, thus blending and softening the colours on the edge of the plate.*

5 *The pattern of the plate is drawn in with a fine sable brush. This stage also demonstrates the positive role played by the coloured ground, patches of which show through the light, cool, neutral colours.*

6 *With the pattern complete, highlights have been added to the plate, but the ground is still visible in places and will not be completely covered, even in the final stages.*

7 *Too much detail in the background would detract from that in the foreground, so the artist suggests the pattern with small dabs of the brush. The pattern of holes in the weave of the basket was created by working small brushstrokes of light green over the brown.*

8 *For the final details on the basket, the painting is turned upside-down to give better access to this area, and a fine sable brush is used to touch in the lines of the weave.*

9 *(Below) In the finished painting, small patches of the coloured ground are still clearly visible, particularly in the blue-green foreground. This has the effect of linking this area with the warm colours of the background and objects.*

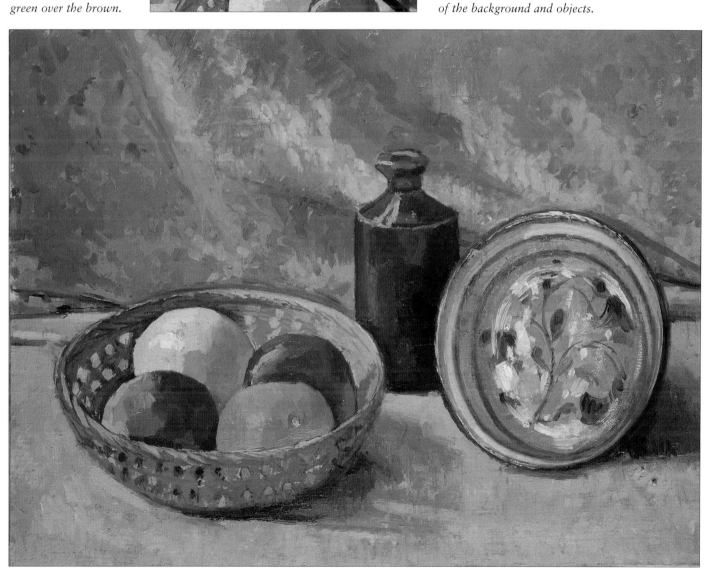

LANDSCAPE

Landscapes need not be painted on the spot – many fine paintings are made from sketches and photographic reference – but when weather permits there is nothing more enjoyable than working direct from the subject out of doors.

Both oil and acrylic are excellent for outdoor work. With acrylic, of course, the paints could dry out on your palette before you are halfway through but, if you use a Stay-Wet palette, this will not happen. The advantage is that the painting will be completely dry when you want to stop work; you can also work on paper instead of canvas or board if you prefer. With oil,

Leading the eye
(Above) *A good landscape gives you the feeling that you can walk into and around it, so the artist must consider ways of leading the eye into the picture. A common device is to use a curving path or river travelling from foreground to middle distance, and in* Vineyard in the Languedoc *(oil) Madge Bright has used the lines of the vineyard in the same way, so that they act as signposts towards the painting's centre of interest: the group of houses.*

Restricting the space
(Left) *The word landscape generally conjures up an image of a wide panorama or perhaps a dramatic mountain view, but anything that is out of doors is a landscape; for those who have no access to open countryside, parks and gardens are an excellent choice. Restricting himself to a landscape in microcosm in his* View of Back Gardens, *Ben Baker has achieved a lively composition in which he has explored contrasts of colour, shape and texture.*

Human interest
(Opposite) *Another way of drawing the eye into the painting is to introduce a figure or figures in the middle distance, as David Curtis has done in* Poppyfield over Misson *(oil). It is a curious fact that, because of the way we identify with them, fellow humans always attract attention. The other function of figures in landscape is to provide scale; here they emphasize the wide expanse of poppy-strewn field.*

Creating space
(Right) *If you are painting a small section of landscape in close-up you do not have to worry unduly about creating a sense of space, but in a panoramic landscape like Timothy Easton's* The Ploughed Edge *it is vital. He has done this in two main ways: firstly by exploiting the perspective effect of the converging lines of ploughing; and secondly by using paler, slightly cooler colours in the distance.*

you will always have a wet painting to carry home, which can be a problem if the painting is large and it is a windy day.

PLANNING THE PICTURE
One of the commonest faults in paintings done on the spot is poor composition –

sometimes even professionals get it wrong. First you must decide what format your painting should take and, secondly, how much of the view you should include.

A further advantage of working with acrylic on paper is that you can let the composition grow "organically". Without much time for planning, because of changing light and so on, mistakes can easily occur; when you are well into a painting you often find that you should have included a certain tree on the right, for example, or made the picture vertical instead of horizontal. The answer is to take a larger piece of paper than you need and leave generous margins when you begin to work; this allows you greater flexibility and the freedom to make any necessary changes.

You cannot do this with oil paintings, unfortunately, because they have to be fitted into the confines of your canvas or board. It is wise to take several working surfaces with you so that you can decide which one best suits the subject. Using a

49

The foreground

(Right)*This can be a problem area in landscape paintings. Because this part of the view is closest to you it is seen in sharp focus, so the natural tendency is to treat it in detail. This can, however, be unwise, as it can act as a block, discouraging the viewer from looking beyond it into the picture. In Timothy Easton's* Dwarf Firs and Cottage *(oil) he has solved the problem by contriving a strong focal point – the figure in front of the house – so that although the foreground flowers claim attention first, the eye then travels over and beyond them.*

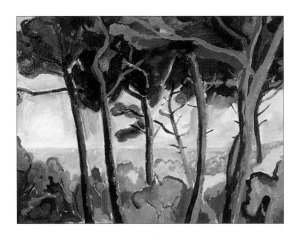

Cropping the foreground

(Above) *Sometimes the foreground in a landscape serves to introduce the view beyond, with a focal point in the middle distance, but it can be the* raison d'être *of the painting, as in Gerry Baptist's* On the Coast of Provence *(acrylic). In order to create space and recession he has employed a traditional compositional device, that of cropping the trees at the top and bottom of the picture. This has the effect of bringing them to the front of the picture, while everything beyond recedes.*

viewfinder is also a good idea, to help you to decide how much of the scene to include. This device is easily made by cutting a rectangular aperture in a piece of card; you can then hold it up at different angles and at different distances from your eyes in order to isolate various sections of the landscape. This can help when you are faced with a wide panoramic view and you cannot decide which bit to focus on, or where the centre of interest lies.

THE FOCAL POINT

Most landscapes have a centre of interest, or focal point, to which the eye is drawn. How obvious this is depends on the scene. Examples of an obvious focal point might include a group of buildings in a landscape, a tall tree, or some people sitting down having a picnic – people always grab our attention because we identify with our

fellow humans. A less obvious focal point might be a ploughed field making a pattern in the middle distance, a particular hill, a gleam of light on a lake or river, or a light tree set against darker ones.

Try to orchestrate the painting so that you set up a series of visual signposts towards the focal point. These will probably already exist, although you may have to exaggerate them. Diagonal lines or curves invite the eye to follow them, and a device frequently used in landscape is a curving path leading from the foreground in towards the middle distance – where the focal point is often located. Alternatives are receding lines of trees, lines of ploughed fields or the stripes of a newly cut hay field. Do not make the foreground too dominant. If the focal point is in the middle distance or the far distance, too much detail in the foreground will detract from it.

CREATING SPACE

A landscape will not look convincing unless you give the impression of space, and there are two principal ways of doing this. One is to observe the effects of linear perspective correctly. Everyone knows that things become smaller the further away they are, but it is easy to under-estimate this effect. You know that a field or a far-away lake is a certain size and you fail to realize that it is actually tiny in relation to the rest of your picture. It is wise to measure such landscape features when you make your preliminary drawing. Hold a pencil or paintbrush up at arm's length and slide your finger and thumb up and down it; in this way you can establish the size of the distant lake in comparison, for example, with a field which is closer.

The other way to create space is to use aerial perspective. Tiny particles of dust in the atmosphere create an effect rather like a series of ever-thickening veils, so that far-away objects are paler than nearby ones. There is far less contrast of tone (light and dark) and the colours change, becoming cooler and bluer. Again, this effect is easy to under-estimate, particularly for features in the middle distance. You know that a tree trunk on the other side of a field is dark brown, so you paint it that way but, in fact, it will be much lighter in tone than it would be if it were in the foreground.

When it comes to far distance, colours can be very pale, although sometimes they appear dark in relation to a still-lighter sky. The contrasts of tone are minimal, sometimes barely distinguishable. A ray of sunshine lighting up part of a distant hill looks dramatic, but the tonal contrast is still relatively limited. These subtle nuances of colour and tone can be tricky, but with practice you will master them.

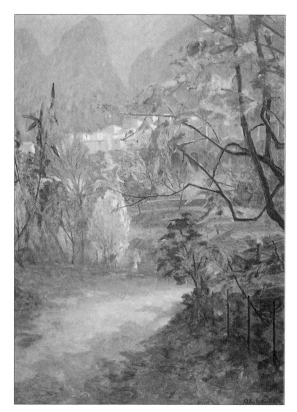

Controlling tones
(Left) *Patrick Cullen's* Landscape in Provence *is first and foremost a painting of light, with the landscape illuminated by the soft, pearly glow of early morning. This reduces contrasts of tone, so the relative lightness and darkness of colours must be controlled extremely carefully. Notice that there are no dark colours here – even the foreground tree and railings are pale whispers of golden brown and green, and the composition is unified by the repetition of delicate mauves, yellows and golds.*

Light and colour
(Below) *The effects of light can completely transform a landscape: colours that looked vivid on a sunny day may seem flat and dull under an overcast sky, and the differences between evening light and a high midday sun are equally striking. Stewart Geddes's lovely* Le Rocher Dongle, Evening *(oil) is as much about light as it is about the landscape itself, and the artist has wisely treated both the buildings and the landscape features very broadly to give full rein to the golden evening colours.*

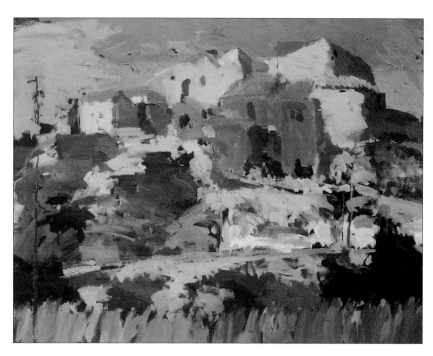

LANDSCAPE DEMONSTRATION

Karen Raney is an experimental artist who works in a number of media and paints a variety of different subjects – indeed, anything which excites her interest. Although she works direct from the subject whenever possible, she also uses photographs as an extensive reference; here she re-creates a landscape from her own photographs, aided by memories of the place, which she has painted many times. She is working in oil on a commercially prepared stretched and primed canvas.

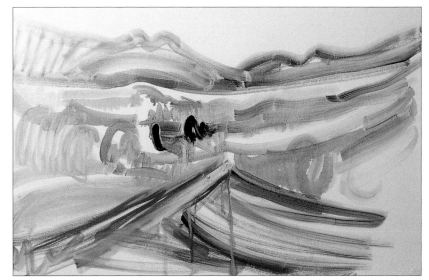

1 *Brushwork is an important element in this landscape, and the artist has begun to exploit it immediately, employing a flat bristle brush to make sweeping strokes of paint diluted with turpentine.*

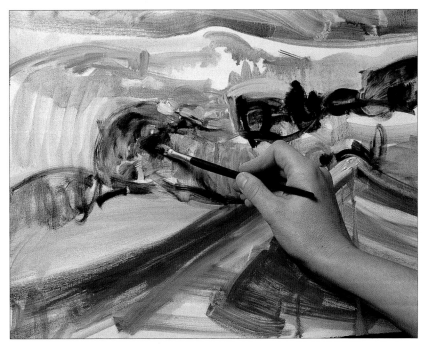

2 *Once the composition has been established with the diluted paint, she begins to use it more thickly, adding a little linseed oil to the turpentine and painting darker colours into the thin washes.*

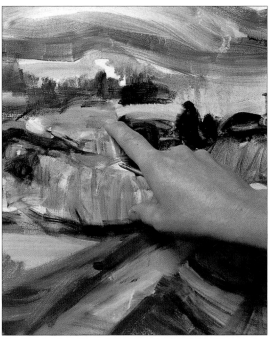

3 *Colours are smeared and blended together with a fingertip. She likes to move paint around as she works, and oil paint, which remains wet for a considerable time, encourages such manipulation.*

4 (Right) *To create the rounded blobs of the trees, a bristle brush is loaded with paint, pushed onto the picture surface and twisted slightly. The paint is then built up more solidly all over the picture; here it is used straight from the tube, with no added medium. Notice the way in which the artist uses the brush-marks to describe the shapes of the roof tiles.*

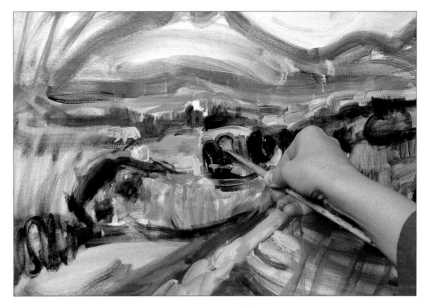

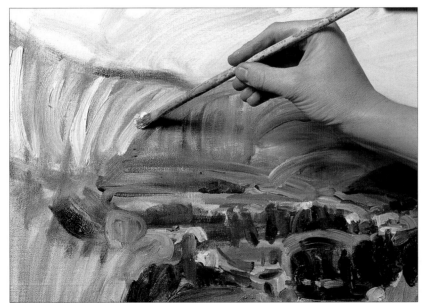

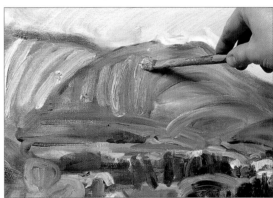

6 (Above) *She takes a less deliberate approach to painting than some artists, letting the picture dictate what she should do next, and experimenting to see what happens. Here she uses upward-sweeping brushstrokes once more, later modifying them slightly.*

5 (Above) *The artist has wiped into the thin paint with a rag to create a striated effect, which she now reinforces with thick white brushstrokes. She works instinctively, seeing that the sweeping roof lines need to be echoed in this area of the painting.*

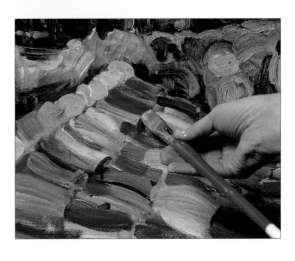

7 (Right) *Having built up the middle ground and distance, she returns to the foreground and introduces darker, richer colours into the roof, using the side of a flat bristle brush to suggest the shadowed divisions between the tiles.*

Continued ▷

8 *The distant village, which is the focal point of the picture, is left until a late stage; it is now treated in the same way as the rest of the painting, with bold brushstrokes describing the shapes and forms.*

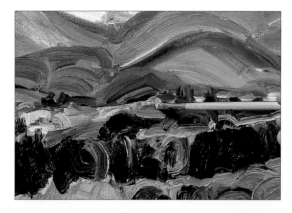

9 *The brushwork depicting the houses can be seen clearly here – vertical strokes for the walls and horizontal for the roofs. The hills behind are now built up more decisively.*

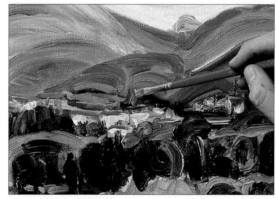

10 *A fingernail scratches into the light paint to reveal a little of the darker colour beneath, which is now completely dry.*

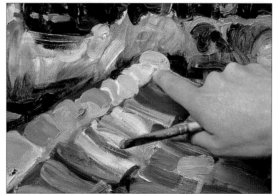

11 *It is important to create visual links between one part of the picture and another, and a little of the light green in the middle ground is now taken into the blue of the hills.*

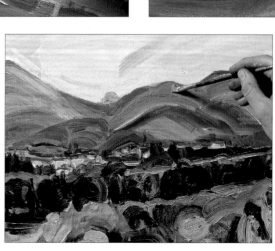

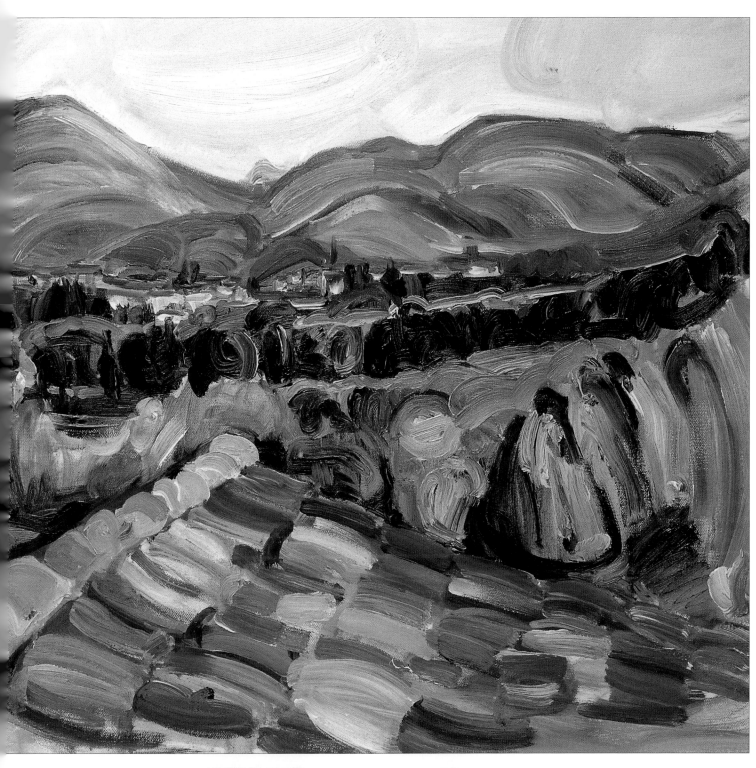

12 (Right) *Strokes of thick, light paint are swept across the sky, with sufficient pressure applied to the broad flat brush to create a series of tiny ridges in each stroke.*

13 (Above) *The finished painting illustrates beautifully what is meant by creating a sense of movement in a composition. The eye is led into and around the painting by the wing-like shape of the foreground roof and by the directional brushwork.*

FIGURES & PORTRAITS

The human figure, whether painted as a portrait, a full-length study, a clothed figure or a nude, presents a greater challenge to the artist than any other subject. A still life may be quite satisfactory even if the ellipse on a vase or plate is not right or the table top is out of perspective. But in figure painting such things do matter – we are all familiar with the general structure and proportions of our fellow humans.

It has to be said that the human figure is not easy to portray; the interaction of forms is complex and subtle. Figure and portrait work relies on drawing as much as on painting. This does not mean that you must make a painstaking and detailed drawing and then fill it in, but you must think about the underlying structure – the drawing – all the time as you work and be prepared to make corrections. Working in opaque paints is a considerable advantage here. With oil you can scrape areas back and repaint them, while with acrylic you can easily correct the drawing by overpainting.

STUDYING THE SUBJECT

Drawing the nude is one of the best ways of studying the figure, and even if you intend to paint only portraits and clothed figures it pays to join a life class. It is not essential, however. What is important is to practise drawing people whenever you can. Ask friends to pose for you; draw yourself in the mirror; take a sketchbook with you and make studies of people walking in the street, sitting at café tables, reading or simply relaxing.

PLANNING THE PICTURE

Whether you are painting a head-and-shoulders portrait, a full-length portrait or a nude figure study, never lose sight of the fact that you are also producing a picture.

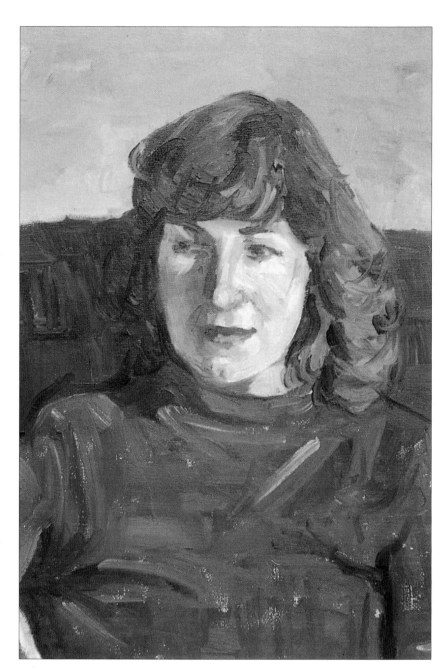

Form and brushwork
(Above) *As the human face and head are complex and difficult to paint, even before you have considered how to achieve a likeness of the sitter, there is a tendency to draw lines with a small brush. This is seldom satisfactory, however, as hard lines can destroy the form. In Ted Gould's Sue (oil), the features, although perfectly convincing, are described with the minimum of detail and no use of line, and the forms of face, hair and clothing are built up with broad directional brushwork.*

Form and colour

(Right) *As a general rule, the colours in shadows are cooler, that is, bluer or greener, than those in the highlight areas, and Gerry Baptist has skilfully exploited this warm/cool contrast to give solidity to the head in his acrylic* Self Portrait. *Although all the colours are heightened, they are nevertheless based on the actual colours of flesh, and the picture is successful in its own terms.*

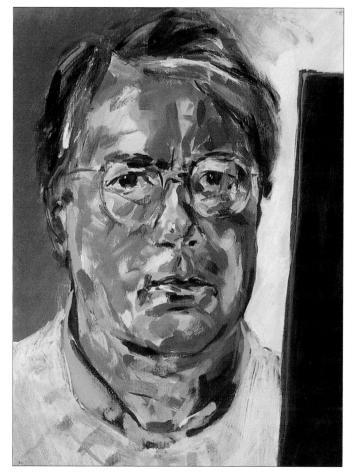

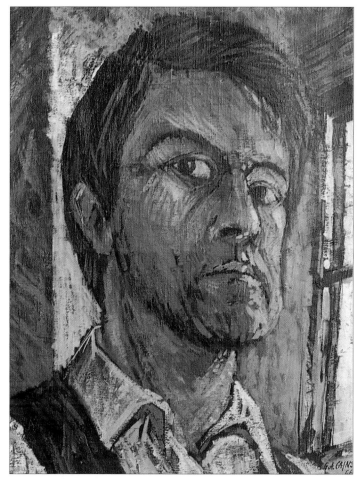

Painting in monochrome

(Left) *In this unusual oil painting,* Self Portrait at 32 Years, *Gerald Cains has taken a diametrically opposite approach to Gerry Baptist and ruled out colour altogether, while using highly expressive brushwork. The effect is extraordinarily powerful. It can be a useful discipline to work in monochrome, as it helps you to concentrate on composition and tonal balance without the distraction of colour.*

In a portrait, particularly, the desire to achieve a likeness can be so all-consuming that you may forget about all the other aspects of the painting.

Much the same applies to figure paintings. The model is often placed right in the middle of the canvas or, worse still, with the feet cropped off at the ankles because they would not fit in. Too much attention is given to the figure and not enough to any other elements in the picture, such as the background. This is understandable, as the figure is the most difficult thing to paint, but it gives a disjointed effect – a good composition is one in which everything is given equal consideration.

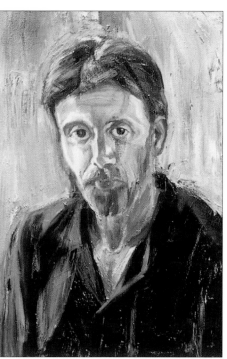

Colour and mood

(Left) *Portraiture involves more than simply achieving a likeness through correct observation of the shapes of noses, eyes and mouths. The best portraits give a feeling of atmosphere and express something of the sitter's character. In Karen Raney's* David *a sense of melancholy and introspection is conveyed through the sombre colours and heavy, downward-sweeping brushmarks as well as by the sitter's intense but inward-looking gaze.*

(Left) *In a figure painting you must decide where to place the figure, whether or not to crop part of it, and whether you need to introduce other elements as a balance. Peter Clossick's* Helen Seated *gives the impression of spontaneity because it is so boldly and thickly painted, but it is carefully composed, with the diagonal thrust of the figure balanced by verticals and opposing diagonals in the background.*

Before you start to paint, consider how you are going to place the head or figure on the canvas. A central placing generally looks stiff and unnatural, as does a direct, face-on approach. Heads in portraits are usually placed slightly off-centre, with the sitter viewed from a three-quarter angle; one shoulder thus appears higher than the other. In this case, more space is often left on the side towards which the sitter is looking, and the near shoulder is sometimes cropped by the canvas edge. Consider how much space to leave above the head. Too much and the head can appear pushed down; too little and it will seem cramped.

LIGHTING

Lighting is vital in portraiture and figure work. The play of light and shade not only describes the forms but also provides the all-important element of tonal contrast. If you look at a face under a harsh, direct light, it looks flat and dull with very little depth, but if the light comes from one side it strikes parts of the face while throwing others into shadow, immediately creating a more interesting configuration. The form of lighting most favoured for portrait and figure work is called three-quarter lighting – the illumination comes from one side,

slightly to the front of the model, thus lighting three-quarters of the face and body.

If you can control the lighting set-up, think also about the strength of the light. Those who paint out of doors will have noticed that bright sunlight casts very positive, heavy shadows. Although strong light can create dramatic effects in a portrait and many artists deliberately choose it, it is not suitable for all subjects. In a painting of a young woman or child, for example, a diffused light is more suitable, as this brings out the subtlety of the flesh tones. If you are painting by a window, you might consider some form of diffuser, such as a net curtain or tracing paper placed over the window. Over-hard shadows on one side of the face can also be lightened by using a reflector. By propping up a white board or piece of paper by the side of your sitter, opposite the source of light, you can bounce some light back onto the dark side of the face, giving touches of colour to the shadow while still preserving tonal contrast.

(Right) *Painting an adult engaged in some typical pursuit can enhance your interpretation, but in the case of children it is a question of necessity; they seldom remain still for long, added to which they look stiff and self-conscious when artificially posed. In her delightful, light-suffused study of* Samantha and Alexis (oil) *Karen Raney has worked rapidly to capture a moment of communication between her two young subjects.*

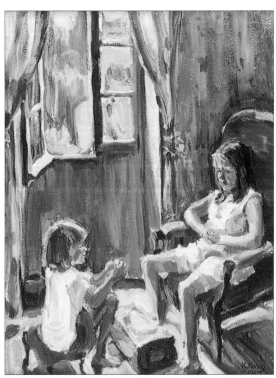

THE FIGURE IN CONTEXT

In a head-and-shoulders portrait, the background is frequently left deliberately vague and undefined in order to focus attention on the face, but a whole figure must be put into a believable context, so some of the room should be included. If you are painting the nude in a life class, you may not have much control over background and other elements, but for a clothed figure painted in your own home or theirs, you will have a wider choice. Particular props are often used in portraiture to help describe the character and interests of the sitter. A writer or someone fond of reading might be shown with a selection of favourite books, or a musician with his or her instrument. Try to convey something of the atmosphere surrounding your sitter.

Full-length portraits

(Above) *When you intend to paint the whole figure rather than just a head and shoulders, you must consider what other elements to include and what props will help to enhance your description of the sitter. If you are painting the subject in their own home, you can show them in familiar surroundings and with personal possessions, as David Curtis has done in his lovely* Interior with Jacqueline *(oil), which is both a portrait and a visual essay on light.*

Outdoor settings

(Right) *Light is also an important element in Timothy Easton's* The Summer Read *and, like David Curtis, he has described the sitter more by posture, clothing and general shape than by detailed depiction of features, indeed the features are barely visible. With careful observation, you will find that it is perfectly possible to paint a recognizable likeness of a person without showing the face at all.*

PORTRAIT DEMONSTRATION

Elizabeth Moore paints landscapes, portraits and still lifes, working in all the painting media, but with a tendency towards oil. She often works from photographs, particularly black-and-white ones, which leave her free to interpret an idea in her own way. This oil painting was initially based on a photograph, but the colours are the product of her imagination and experience.

1 (Right) *The sketches, two in pencil and one in oil pastel, were made to explore possible compositions and work out ideas about the general colour scheme for the portrait.*

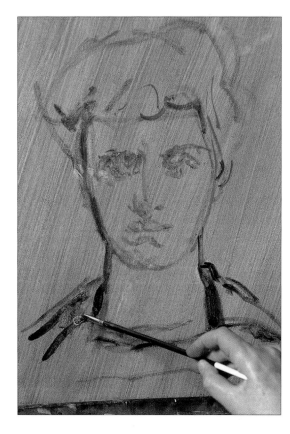

2 *The artist is working on primed and stretched canvas, which she has coloured with a rich yellow-brown to provide a foundation for the flesh tints. She begins with a brush drawing in green, the colour to be used for the dress.*

3 (Right) *The deep, rich purple of the background is painted first, in order to assess the colours needed for the face. Without a live sitter, the artist is working blind in a sense, and must relate the colours to each other rather than to reality.*

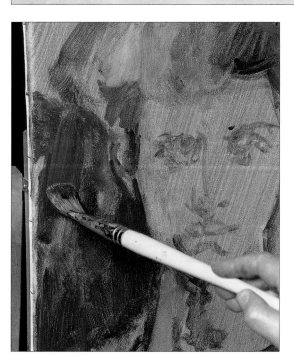

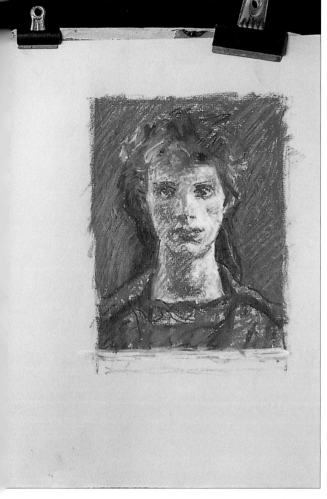

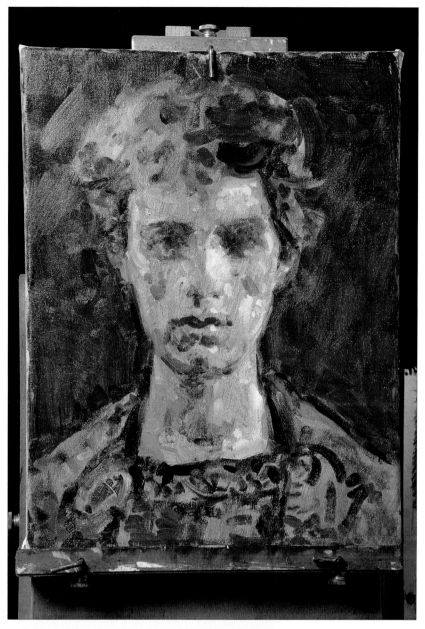

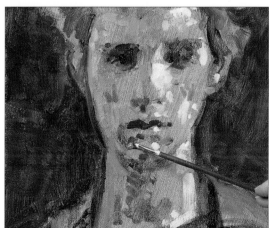

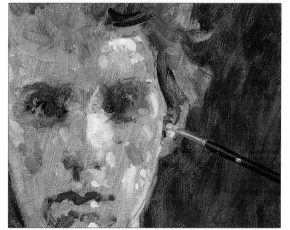

6 (Above) *At this stage in the painting, the artist takes a break for assessment, standing well back from her easel to check whether the colours work when viewed from a distance.*

4 *She proceeds to lay down patches of colour on the face, neck and garment, concentrating on the lightest and darkest tones. She keeps the colours as pure as possible, doing the minimum of mixing and employing an unusually large palette of colours to capture the subject accurately.*

5 *Having used a modified version of the background purple for the shadowed eye sockets, she builds up the light side of the face. To avoid these pinks merging into the darker colour, she places them carefully with a small pointed bristle brush, which gives more control than a flat brush.*

Continued ▷

7 *In any portrait, but particularly one in which the subject is looking straight ahead at the viewer, the eyes are the focal point; the eyes and eyelids are defined carefully here with delicate touches of a filbert brush.*

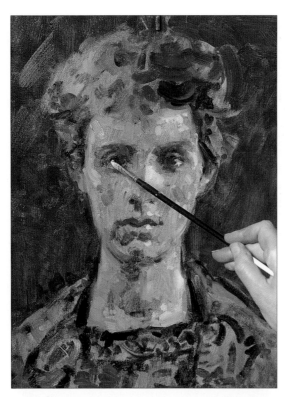

8 *The face is sufficiently well-established for the artist to turn her attention to other parts of the painting, and a small round brush, held lightly towards the end of the handle, traces the pattern on the dress.*

9 *The purple of the background was too warm a colour and needed some variation, so deep blues are introduced. In the classic fat over lean method, the paint now used is thicker and oilier than in the early stages.*

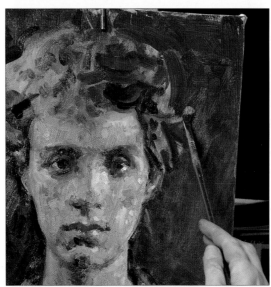

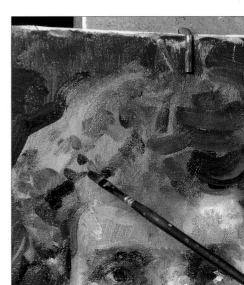

11 *The top of the eye socket is darkened with deft touches of a small brush. Although the painting is nearing completion, much of the ground colour has been left uncovered, and the small dabs of pink, red and green on the face remain separate and unblended.*

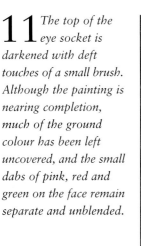

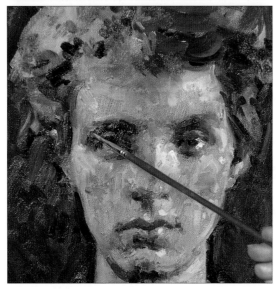

10 *The green of the dress, which is mirrored in parts of the face and the deep shadow on the neck, is repeated in the hair, so that the head and clothing are linked by a common colour.*

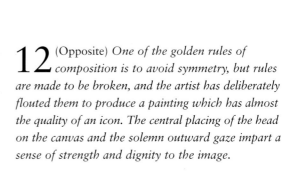

12 *(Opposite) One of the golden rules of composition is to avoid symmetry, but rules are made to be broken, and the artist has deliberately flouted them to produce a painting which has almost the quality of an icon. The central placing of the head on the canvas and the solemn outward gaze impart a sense of strength and dignity to the image.*

INDEX

PUBLISHER'S ACKNOWLEDGEMENTS

The author and publisher would like to thank the following companies for supplying materials used in the making of this book:

Cornelissen & Son Ltd
105 Great Russell Street
London WC1B 3RY
(020) 7838 1045

Daler-Rowney Ltd
PO Box 10
Southern Industrial Estate
Bracknell
Berkshire RG12 8ST
(01344) 424621

Russell & Chapple Ltd
Canvas & Art Materials
23 Monmouth Street
London WC2H 9DE
(020) 7836 7521

Winsor & Newton
Whitefriars Avenue
Wealdstone, Harrow
Middlesex HA3 5RH
(020) 8427 4343